Magic Lantern Guides

Canon
EOS 5D

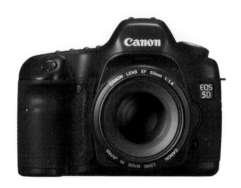

Mimi Netzel

LARK BOOKS
A Division of Sterling Publishing Co., Inc.
New York

Editor: Kara Helmkamp
Book Design and Layout: Michael Robertson
Cover Designer: Thom Gaines
Editorial Assistance: Delores Gosnell and Dawn Dillingham

Library of Congress Cataloging-in-Publication Data

Netzel, Mimi Ann.
 Canon EOS 5D / Mimi Ann Netzel. -- 1st ed.
 p. cm.
 Includes index.
 ISBN 1-57990-884-5 (pbk.)
 1. Canon camera--Handbooks, manuals, etc. 2. Digital cameras--Handbooks,
manuals, etc. I. Title.
 TR263.C3N48 2006
 771.3'3--dc22

 2006020563

10 9 8 7 6 5 4 3 2

Published by Lark Books, A Division of
Sterling Publishing Co., Inc.
387 Park Avenue South, New York, N.Y. 10016

Distributed in Canada by Sterling Publishing,
c/o Canadian Manda Group, 165 Dufferin Street
Toronto, Ontario, Canada M6K 3H6

Distributed in the United Kingdom by GMC Distribution Services,
Castle Place, 166 High Street, Lewes, East Sussex, England BN7 1XU

Distributed in Australia by Capricorn Link (Australia) Pty Ltd.,
P.O. Box 704, Windsor, NSW 2756 Australia

If you have questions or comments about this book, please contact:
Lark Books
67 Broadway
Asheville, NC 28801
(828) 253-0467

Manufactured in USA

ISBN 13: 978-1-57990-884-3
ISBN 10: 1-57990-884-5

For information about custom editions, special sales, premium and corporate purchases, please con-
tact Sterling Special Sales Department at 800-805-5489 or specialsales@sterlingpub.com.

Contents

Introduction

Canon saw a need (and a market) for a digital camera that fit squarely between the EOS 20D and the professional EOS-1D series. Therefore, the EOS 5D was newly created rather than upgraded from a previous Canon digital SLR (D-SLR). It combines a full-frame, 12.8 megapixel sensor with a relatively lightweight, compact body. It weighs in at 35.8 ounces (895 g) with battery. By comparison, the 20D weighs 24.2 ounces (770 g) and the 1Ds Mark II is 62.6 ounces (1565 g). Its price point is also closer to the 20D than the 1Ds Mark II.

Compared to the EOS 20D, the 5D's sensor has not only more pixels, but also larger pixels. The larger pixels can gather more light to produce better image quality, a wider range of ISO settings, and lower noise levels. While Canon doesn't categorize the EOS 5D as a professional D-SLR, the image quality is comparable. The camera produces image files at a resolution that is high enough to be reproduced as a two-page magazine spread.

Canon developed a durable shutter specifically for the camera's full-frame sensor. It is rated to 100,000 shots, another feature that puts the 5D on a par with professional cameras. However, one important feature that the 5D lacks when compared to the professional 1D-series models is environmental seals. It is just not designed to withstand the more rigorous use and conditions that professional cameras see. There is no doubt the 5D will appeal to EOS 20D owners looking to upgrade. However, these photographers may be disappointed if they have invested heavily in EF-S lenses. The 5D can use any other Canon EF lenses, but not the EF-S mount.

⟡ *The EOS 5D has a full-frame 12.8 MP CMOS sensor. It can produce a RAW or JPEG file with a maximum resolution of 4368 x 2912 pixels.*

The Basics of Digital Photography

The EOS 5D is not a basic camera, but the basics of digital photography still apply. However, the standards of digital image making are changing constantly with advances in technology. Improvements are made to sensors and processors, new file formats are created, and features are upgraded. It can be difficult to keep up with the changes being made. Some photographers even harbor misconceptions about digital photography based on out-of-date information. It is easy to fall behind in the fast-paced world of digital images.

Canon EOS 5D

The best way to learn digital photography is to go out and take pictures. Carry your camera so you can snap interesting scenes. Then, review your photos on the LCD Monitor to check composition, exposure, and white balance. ©Marti Saltzman

Although the 5D is not necessarily a camera for beginners, it may be a camera upgrade for a photographer or the first D-SLR for a serious amateur shooter. Even if you've used a digital camera for years, you may want to reacquaint yourself with the basics. Photographers who have used film cameras until this point may not be familiar with all the differences (and advantages) of digital photography. Setting a file format, using the LCD Monitor and histogram, and understanding the latest sensor technology may be new information.

For the photographers who are new to D-SLR photography, we will explain basic topics that are central to digital photography. You will get the most from your camera if you understand its key features and when to use them. You don't necessarily need to know how to operate every function. Once you comprehend a feature, you may decide it is not necessary to master it in order to achieve your desired photographic results. Explore those that work for you and forget the rest. There's no mystical commandment stating that you must become completely familiar with every operational detail. If you are familiar with these terms and concepts, skip ahead to the detailed sections on camera operation.

Features Unique to Digital Photography

Though many of the features on traditional Canon EOS film cameras are also found on their digital counterparts, there are some controls and operations unique to digital cameras. There are functions that have been added to increase the camera's versatility for different shooting styles and requirements and some can provide real improvements to your photography. The goal of this manual is to help you understand how your digital camera operates so that you can choose the techniques that work best for you and your style of photography.

LCD Monitor

One major advantage that digital cameras have over film cameras is the ability to evaluate an image on the LCD monitor just moments after the photo is taken. With a digital camera, it is easy to check exposure, composition, depth of field, white balance, and other aspects of an image on the spot. Remember, while this tiny version of your image isn't perfect, it will give you a good idea of how the image looks. This has been a huge enhancement for photographers at every level. For beginners, the LCD monitor is a learning tool. For professionals, it is an insurance policy.

While an LCD may not reveal as much as a computer monitor, it provides a pretty good representation the image that has been recorded. The 5D has the added feature of being able to enlarge an image up to 10X on the monitor. This is especially useful for checking details, such as facial expressions in a portrait. If your subject blinked, you'll see it and you can easily snap another shot.

Histograms

As mentioned, the LCD monitor is a useful tool for checking an image, but don't just look at the photo you've taken. If you're using the monitor to judge exposure, you'll want to look at the histogram display. The histogram is a graphic representation of the tones in a digital photograph. The tonal range runs from darkest (left) to lightest (right) along the horizontal axis. The vertical axis displays the frequency of each tone. As a generalization, the histogram of a properly exposed image will look like a bell curve. If most of the information is on the right side of the histogram, this may indicate that the image is underexposed. If the data looks like it has all been pushed over to the left side of the graph, this indicates overexposure.

One thing that remains true, whether you are shooting film or digital, is that incorrect exposure will result in unsatisfactory images. Digital cameras are not magic and can't circumvent the laws of physics: too little light produces dark images; too much makes overly bright images. The histogram

is just another useful feature—unique to digital photography—that can assist you with image evaluation.

Highlight Alert
The 5D also has a Highlight Alert to indicate the possibility of overexposure. When you review an image on the LCD monitor, overexposed areas of the image will blink. This indicates that they are pure white with no detail. If the spots are small, specular highlights, such as reflections on water or an illuminated light bulb in the background, the lack of detail may be acceptable. If a large portion of the image or an area that should have detail is overexposed, try setting negative exposure compensation and reshoot the image.

Digital Image Capture

Both film and digital cameras expose pictures using virtually identical methods. The light metering systems are based on the same technologies. The shutter and aperture mechanisms that control exposure are the same. These similarities exist because film and digital cameras have the same function—to create an image by delivering a controlled amount of light a light-sensitive medium. Of course, there are some differences. Film is both the light-sensitive material that records an image and also the storage medium. Digital photography is more of a two-part process: the image is captured by the sensor and stored on a memory card.

The Sensor
A "traditional" camera exposes film to light, a chemical reaction occurs, and an image is produced. With a digital camera, the light strikes a sensor covered with photosensitive diodes. When light reaches the sensor, each diode accumulates an electrical charge. The strength of that charge varies with intensity of the light. The analog electrical signal from each diode is converted to a digital signal that can be processed by the camera's microprocessor.

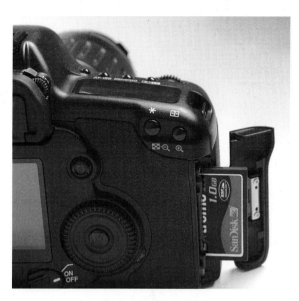

Images are stored on a CompactFlash card that is inserted on the right side of the camera. When the Card Slot Cover is opened, the camera powers off automatically.

The dynamic range of the EOS 5D's sensor is about 8 stops, approximately the same as slide film. However, digital sensors respond differently to light than film. A digital sensor responds to the full range of light equally, or linearly. Film, however, responds linearly only to midtones, there is decreased contrast in the darkest and lightest tones. Therefore, film blends tones very well in highlight and shadow areas. Digital sensors are more likely to lose detail in these areas, especially the brightest tones.

Memory Cards

Memory cards are the second component of digital image capture. The image captured by the 5D's sensor is processed and then written to a CompactFlash (CF) memory card. CompactFlash cards are necessary to take and store images with the 5D. These removable cards offer several advantages over film.

Standard 35mm rolls of film have either 24 or 36 exposures. Memory cards come in a range of capacities, and all but the smallest are capable of holding more exposures than a roll of film. In the space taken up by just a couple of rolls of film, a few memory cards will hold hundreds of images. Professional photographers who use film may carry hundreds of rolls when they shoot on location. The same number of images can be held on a few high-capacity memory cards and carried in a coat pocket. Memory cards are also more durable than film. They can go through the x-ray machine at the airport without fear of image degradation. Photographers have claimed to wash them or drop them into water with no ill effect. This isn't recommended and they should be allowed to dry before you use them. Heat will damage them; so don't put them in the dryer.

Have you ever ruined a roll of film by accidentally opening your camera when it's loaded? Fortunately, this can't happen with a memory card because it isn't light sensitive. However, an image can fail to be recorded if you try to remove a card while the camera is reading or writing data to the card. If the access lamp is not lit or blinking or LCD panel does not have "Busy" displayed, a CompactFlash card can be inserted or removed without risk to the images. As a safe guard, the 5D powers off when the CF card slot cover is opened.

A memory card may be more costly than a roll of film, but once a roll of film is exposed, you can't reuse it. The more pictures you take with film, the more rolls you have to buy. Memory cards can be used again and again. You can erase the photos on a memory card at any time, removing the ones you don't want and opening space for additional photos. Once images are transferred to your computer (or other storage medium), the card can be erased and reused. The average cost per image decreases as card use increases. Keep this in mind when you're using your digital camera and take extra photos, try new, creative ways of shooting, and expand your skills.

If you're going out for a day of shooting, make sure you have ample capacity for image storage. Memory cards can fill up quickly—a 1GB card will hold less than 60 RAW files or about 200 large, fine JPEG files.

ISO

ISO is an internationally standardized rating used to denote film's sensitivity to light. A film's ISO number is also referred to as its speed. Low ISO numbers, such as 50 or 100, represent films with less sensitivity and are considered slow films. Films with high numbers are more sensitive to light and are called fast films. As you double the ISO number, you double the film's sensitivity to light. Film rated at ISO 200 is twice as sensitive to light as ISO 100 film. Typically, lighting conditions are a major factor in determining the film speed that you use. On a sunny day, 100-speed film is fine, but at dusk you may need to switch to a faster film, especially if you are handholding the camera.

Obviously, a digital camera doesn't use film, so why does the 5D have an ISO setting? Most digital cameras, including the 5D, can adjust the sensor's sensitivity to light. Manufac-

turers label these settings with ISO film speed equivalents, because the ISO system is a well-understood photographic standard. If you're using a digital camera set to ISO 400, you can expect that your exposure readings would be equivalent to shooting with ISO 400 film.

With a digital camera, you change the sensitivity of the sensor from picture to picture. It's like changing the film speed with just the touch of a button. This capability provides many advantages. For example, you could be indoors using an ISO setting of 800 so you don't need flash, and then follow your subject outside into the blazing sun and change to ISO 100. The 5D's ISO settings can be adjusted from 100 to 1600 in 1/3-stop increments with additional ISO settings of 50 and 3200.

Sensor Noise

People often equate noise in digital images to grain in film photography. It appears as an irregular, sand-like texture that, if large, can be unsightly and, if small, is essentially invisible. In film, grain occurs due to the chemical structure of the light sensitive materials. In digital photography, sensor noise occurs for several reasons: sensitivity, temperature, pixel size, exposure time, and lighting conditions.

If the ISO setting or sensitivity of a digital camera's sensor is increased, the appearance of noise will increase. Higher temperatures, including heat produced by the camera's electronics, will produce more noise. Noise produced by pixel size isn't an issue with most current D-SLR cameras. Small sensors with small pixels will tend to produce noise. On any camera, noise will be more obvious with long digital exposures, in low-light conditions, and when an image is underexposed.

The ISO setting adjusts the light sensitivity of the camera's sensor. ⇨
ISO 100 or 200 is fine for shooting outside on a sunny day.
©Marti Saltzman.

The EOS 5D's Custom Function C.Fn-02 gives the user greater control over the in-camera, noise reduction processing. OFF (0) is the default setting. Auto (1) will process an image for noise reduction if an exposure is longer than 1 second and noise is detected. ON (2) will process any image for noise reduction if the exposure time is longer than 1 second. See page 84 for more information.

File Formats

The EOS 5D can record digital data as two possible image file formats: JPEG and RAW. Technically, JPEG is a standardized "lossy" compression method that creates the most common file type captured by digital cameras. Digital cameras use this format because it reduces the size of the file, allowing more pictures to fit on a memory card. A disadvantage of the JPEG format is the loss of quality that can occur with image compression. This is especially apparent with JPEG files that have been opened and saved repeatedly.

RAW image files contain the unprocessed data from the camera's sensor. Camera settings, such as ISO, white balance, sharpening, and color saturation, are recorded in the image metadata. They are tagged onto the RAW file, but the image data remains unchanged. RAW files are considered to be a better choice for "professional quality photography." They preserve the original image data and provide more creative control without image degradation. Various affects can be tried without altering the original image data. One disadvantage of the RAW file format is that it is proprietary. Every manufacturer uses its own version and as new cameras are developed, so are new variations of the RAW format. Frequent updates to image-processing software are required to ensure compatibility with the latest RAW file formats.

Both RAW and JPEG files can produce excellent results. The intended use for an image should help you to determine which format to choose. Large prints or professional applications that may require an image to be heavily manipulated

should be captured as RAW files. Also, the unprocessed data of a RAW file can be helpful when faced with tough exposure situations. The small size of a JPEG file is faster and easier to deal with, and it can produce perfectly acceptable images. In fact, most of the images in this book were captured as JPEGs.

Light and Color

The color of light can vary widely and although our eyes adapt to the differences, film does not. A film must be balanced or matched to the color of the light that will create an exposure. Shooting daylight film under artificial lighting conditions can produce some less than pleasing results. We've all seen photos that have a greenish cast because they were shot under fluorescent lighting.

Digital photography has really changed all of this for the better. Digital cameras use a white balance function to adjust how color is reproduced under different lighting conditions. White balance has been a standard part of video ever since portable color cameras became available. A digital camera uses similar technology. Sensors identify white areas of an image and make adjustments to the color balance so those areas will reproduce as white. An overall color correction is applied to the image based on the adjustments made.

Generally, white balance works very well and it's much easier and cheaper than carrying color-correction filters. The key to using white balance properly is to understand the color properties of light. The photographer can then control color reproduction for accuracy or creativity as he or she sees fit. For more information on using white balance, see pages 53-61.

Features and Functions

Canon has filled a niche with the EOS 5D. It offers many of the features of a professional-level camera, but in a smaller, lighter package and at a more affordable price. The camera is lightweight yet durable, with a magnesium-alloy body built over a stainless steel chassis. The full-frame, 12.8 megapixel CMOS sensor designed specifically for the 5D boasts an impressive 4368 x 2912 pixels. One big advantage here is that a lens of any focal length produces the same effect as it would with a 35mm film camera. There is no lens magnification factor, which is especially significant for shooters who use wide-angle lenses.

The 2.5-inch LCD Monitor is a huge asset for image review. Canon has added Picture Style color control to give the photographer more options for capturing images that require less post-processing. The quick start-up and fast card writing speeds match the performance of recent professional-level cameras. The DIGIC II image processor allows for shooting speeds of up to 3 frames per second (fps), not as fast as some other models. However, in continuous shooting mode the 5D can capture a total of 60 large JPEG or 17 RAW files. This beats any of the currently available Canon cameras.

Camera manufacturers today offer a large number of features with their cameras. They do this to appeal to many buyers, but you may not need or use all of them. This book will give you an idea of what is possible with the many features available, as well as help you best utilize those that are most important. But in any case, you should not feel guilty if you don't use every option packed into this camera!

◁ *The 5D's full-frame sensor maintains a lens' stated focal length with no magnification factor. This is a significant advantage when shooting with a wide-angle lens. ©Marti Saltzman.*

Remember, you can't "waste film" with digital cameras. Shoot as much as you want and then erase those images that don't work. This is important because it means you can literally try out every feature contained on your camera and actually see how it functions. This is a quick and sure way of learning to use your camera, and allows you to choose those that are most useful to you.

Overview of Features
- Full-frame D-SLR with a 12.8 megapixel CMOS sensor.
- Strong and lightweight magnesium alloy over a stainless-steel chassis.
- DIGIC II image processor can capture 60 consecutive JPEG or 17 RAW files at a rate of 3.0 fps.
- Large 2.5-inch LCD Monitor with approximately 230,000 pixels.
- Easy-to-see, wide LCD Monitor viewing angle of 170°.
- Autofocus system features nine selectable AF points with six supplemental points to assist with focus tracking.
- Picture Style function allows the photographer to customize color, contrast, and sharpness for the subject.
- Start-up time of 0.2 seconds.
- Shutter release lag time of only 75 milliseconds.
- High-speed shutter, up to 1/8000 second with flash sync up to 1/200 second.

Note: When the terms "left" and "right" are used to describe the locations of camera controls, it is assumed that the camera is being held in the shooting position.

Canon EOS5D – Frontview

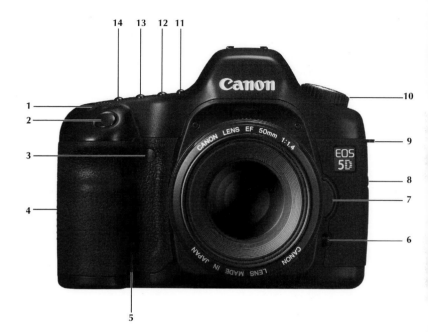

1. Main Dial 📷 page 33
2. Shutter button page 35
3. Red-eye Reduction/
 Self-timer lamp page 113
4. Grip (battery compartment)
 page 31
5. DC coupler cord hole
6. Depth-of-field Preview
 Button page 104
7. Lens release button
 page 104
8. Terminal cover (side)
9. Strap mount (side)

10. Mode Dial page 104
11. LCD Panel illumination
 button ☼
12. AF•WB (AF mode selection/
 White Balance selection
 button) page 53
13. DRIVE•ISO (Drive mode
 selection/ISO speed button)
 page 94
14. Metering mode selection/
 Flash exposure compensa-
 tion button 🔘•⚡ page 95

Canon EOS5D – Rearview

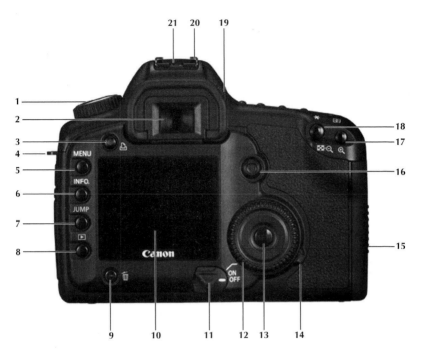

1. Mode Dial page 104
2. Viewfinder eyepiece
3. Direct Print button 🗛
 page 157
4. Strap Mount
5. Menu button <MENU>
 page 70
6. Info/Trimming orientation
 button <INFO> page 75
7. Jump button <JUMP>
 page 70
8. Playback button ▶
 page 74
9. Erase button 🗑
 page 80
10. LCD Monitor page 35
11. Power/Quick Control Dial
 switch ☜ page 30

12. Quick Control Dial ○
 page 33
13. Set button (SET) page 34
14. Access lamp
15. CF card slot cover
16. Multi-controller ✦
 page 34
17. AF point selection/Enlarge
 button ⊞/⊕ page 117
18. AE lock/FE lock/Index/
 Reduce button ✱/⊞·⊖
 page 110
19. Dioptric Adjustment Knob
 page 39
20. Hot Shoe
21. Flash-sync contacts

28

Canon EOS5D – Topview

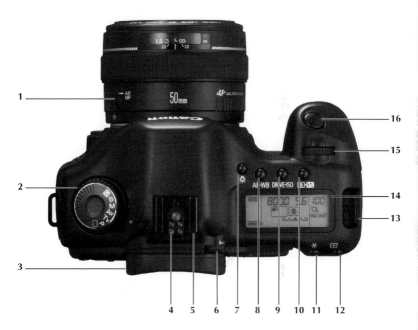

1. *Focus mode selector (on lens)*
2. *Mode Dial page 104*
3. *Eyecup*
4. *Flash-sync contacts*
5. *Hot Shoe*
6. *Dioptric adjustment knob page 39*
7. *LCD panel illumination button* ☼
8. *AF mode selection/White balance selection button* AF·WB
9. *Drive mode selection/ISO speed button* DRIVE·ISO *page 94*

10. *Metering mode selection/ Flash exposure compensation button* ⊙·🔄 *page 95*
11. *AE lock/FE lock button/ Index/Reduce button* ✻/▣·🔍 *page 110*
12. *AF point selection/Enlarge button* ⊞/🔍 *page 117*
13. *Strap mount*
14. *LCD panel page 36*
15. *Main Dial* 〰 *page 33*
16. *Shutter button page 35*

Camera Activation

☜ Power Switch

The 5D has a three-position Power switch ☜ found on the back of the camera below the LCD Monitor. The three positions are OFF, ON, and ON with use of the Quick Control Dial ⊙ . The icon for the third position is an angled line ⌒ drawn from the ☜ to the ⊙ . The ☜ must be in this position to use the ⊙ for setting the aperture in Manual mode and exposure compensation.

Auto Power Off

Like most digital cameras, the EOS 5D will power down if the camera has been idle for a period of time. This conserves battery power. If the camera "goes to sleep," operating any camera control will "wake it up." The Auto power off option in the Set-up menu ⛏ allows you to adjust the how long the camera will remain on. The default time for this setting is only one minute. To change the setting, press the Menu button (on back of the camera to left of LCD Monitor) and select the Set-up menu ⛏ using the Jump button. When ⛏ is highlighted, Auto power off is the first option in this Menu. Press the Set button (SET) in the center of the Quick Control Dial ⊙ to access the seven settings: 1, 2, 4, 8, 15, 30 minutes or Off. If you set this feature to Off, the camera will remain on as long as the Power switch ☜ is in the ON position. Use the ⊙ to scroll to the desired setting, and then press the (SET) .

Auto power off is helpful to minimize battery use, but you may find it frustrating if you miss a shot because the camera has shut itself off. For example, you might be photographing a steeplechase and you've positioned yourself to get that perfect picture of the horse going over the hedge. If Auto power off is set for one minute, the camera may power down while you wait for your shot. When you press the shutter release, there will be a delay because the camera is powering back up. Even though this delay is only a fraction of a second, you may still miss the shot. You might want to change the Auto power off setting, so that the camera stays on for a longer period of time.

Restore Default Settings

With the many adjustable settings on the 5D, it is possible to set so many combinations that at some point you decide to reset it all. To restore the default settings, press the Menu button and select the Set-up menu ¶↑ by pressing the Jump button. When the ¶↑ is highlighted, use the Quick Control Dial ◯ to scroll to Clear settings. Press the Set button (SET) and turn the ◯ until Clear all camera settings is highlighted, then press the (SET) again. You'll have the chance to cancel this operation; Cancel is the highlighted option. If you want to reset the camera, turn the ◯ so OK is highlighted and press (SET) .

Power Source

The 5D is normally powered by one compact, lithium ion (Li-ion) rechargeable battery. A Canon BP-511A battery pack is supplied with the camera, but a BP-511, BP-512, or BP-514 can also be used with the camera. The 1390mAh BP-511A and BP-514 hold roughly 25% more power than the older BP-511 and BP-512 with only 1,100mAh. Milliamp Hours (mAh) indicate a battery's capacity to hold a charge.

The camera is designed to use battery power efficiently. However, power consumption is highly dependent on how frequently certain features, such as autofocus and the LCD Monitor, are used. The more the camera is active, the shorter the battery life, especially with regard to the LCD Monitor. The other variable that affects battery life is temperature. Canon estimates that at 68° F (20° C), you'll get approximately 800 shots from a freshly charged battery. At 32° F (0° C), the number of photos drops to about 400. It's a good idea to carry backup batteries and to shut the camera off when it's not in use.

The BP-511A is rated at 8.4 volts and it takes about 100 minutes to fully charge on the CG-580 charger that is included with the camera. The CG-580 is a one-piece compact unit with built-in, foldout prongs that fit a standard household outlet. All the batteries that can be used with the EOS 5D can be charged in the CB-5L charger supplied with older cameras.

If you want longer battery life, the accessory BG-E4 Battery Grip uses two BP-511A or equivalent batteries to double the number of shots you can take. In addition, the grip comes with a BGM-E2 adapter that allows six AA-size batteries (alkaline, lithium, or Oxyride) to be used. The grip attaches to the bottom of the camera and includes a separate vertical-grip shutter button and Main dial.

Camera Controls

The EOS 5D uses icons, buttons, and dials common to all Canon cameras. Specific buttons will be explained with the features they control. Many of the most common and important functions have several control options to provide greater flexibility to the user.

Main Dial
Located behind the Shutter button on the top right of the camera, this dial allows you to use the index finger of your right hand (your "shooting" finger) to scroll through settings, such as shutter speed and aperture. For a number of other adjustments, it works in conjunction with buttons that are either pressed and released or are held down while the Main Dial is turned.

Quick Control Dial
The Quick Control Dial is located on the back of the camera next to the LCD Monitor. Use your right thumb to turn the dial clockwise or counter-clockwise to adjust camera or menu settings. The dial can be used to scroll through menu items, select the AF point, set white balance, ISO, or flash exposure compensation. First, you must press the appropriate operational button, then turn the dial to adjust the setting as desired.

Operations that use battery power and can decrease the number of shots you get with a fully charged battery include using the LCD Monitor, taking long exposures, and frequent refocusing.

The Quick Control Dial ⊙ has two additional functions when the Power switch ◷ is aligned with the angled line ⟋ . Then, the dial can also be used to set exposure compensation and to set the aperture in Manual exposure mode.

(SET) The Set Button

The Set button (SET) is located in the center of the Quick Control Dial ⊙ . It is used with the Quick Control Dial ⊙ to select Menu choices. When choosing a Menu option, the Quick Control Dial ⊙ is used to scroll to a desired setting and pressing the Set button (SET) activates that setting.

✳ Multi-controller

The Multi-controller ✳ looks like a small button on the back of the camera directly above the Quick Control Dial ⊙ . It works like a mini joystick that you operate with your thumb. There are eight directional keys or hot spots around the outer edge and one at the center. Use the Multi-controller ✳ to select an AF point, set white balance correction, scroll around a magnified image on the LCD Monitor, and adjust the trimming frame with direct printing. The Multi-controller ✳ takes a delicate touch and can take a little practice to accurately hit the desired position.

Shutter Button

The 5D features a soft-touch electromagnetic shutter release. Partially depressing the Shutter button activates the autoexposure and autofocus features. Pressing the button completely releases the shutter with virtually no delay and takes a picture.

In One-Shot AF mode, pressing the Shutter button halfway sets the focus and exposure. As long as the button is held down halfway, the camera will hold the focus and exposure settings. If you're using either AI Focus or AI Servo as an autofocus mode, the camera will continuously adjust focus for a moving subject as long as the Shutter button is partially depressed.

The LCD Monitor

The LCD monitor is probably the one feature of digital cameras that has most changed how we photograph. Recognizing its importance, Canon has designed a 2.5-inch, high-resolution TFT LCD Monitor for the EOS 5D with some exciting features. The LCD Monitor displays the image almost instantly after a photo is taken, and with 230,000 pixels, this screen offers excellent sharpness. Both features are extremely useful for evaluating images.

The big innovation is the monitor's increased viewing angle of 170°. The image or menu on the LCD Monitor can be easily seen with the camera held at almost any angle. The EOS 5D's monitor maintains a consistent level of brightness from any viewing angle. This is an improvement over previous Canon models, particularly when viewing the LCD from

The controls for information and image display are located to the left of the LCD Monitor.

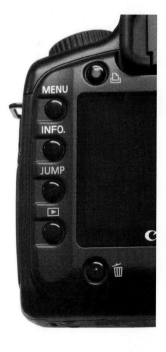

a vertical angle. Also, there is an adjustment for LCD brightness in the Set-up menu 🔧 .

For easier image viewing during Image Playback, the camera can be set to rotate vertical images in the LCD Monitor. With the Auto Rotate feature off, each image is shown as large as possible, but vertical images appear sideways on the Monitor. The Auto Rotate function displays vertical images smaller, but verticals can be viewed properly without having to rotate the camera. Note that Auto Rotate is only in effect when Image Playback is used. During the quick review when the image is shown right after capture, the image fills the LCD Monitor and it's orientation is not changed.

You can also magnify an image up to 10x on the monitor. When an image is enlarged, you navigate around the image and inspect it all by using the Multi-controller ✹ . A "map" appears in the lower right corner of the LCD Monitor that shows the portion of an image being viewed. To view the next or previous image at the same magnification and scroll position, turn the Main Dial 🔄 or the Quick Control Dial ⊙ .

When reviewing images, the LCD Monitor can also display a great deal of shooting data, such as exposure mode, exposure settings, either an RGB or brightness histogram, white balance, and AF point, along with each shot. The ability to see the recorded picture combined with all this information means that under- and overexposures, color challenges, lighting problems, and compositional issues can be dealt with in an informed way.

The LCD Panel

Not to be confused with the LCD Monitor, the LCD Panel is on the top of the 5D to the right of the pentaprism. It displays camera settings and shooting information, such as exposure, white balance, drive settings, metering mode, battery life, and image quality. The LCD Panel is always

LCD Panel

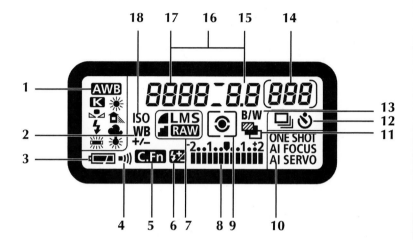

1. White balance
2. White balance correction
3. Battery check
4. Beeper
5. Custom Function
6. Flash exposure compensation
7. Image-recording quality
8. Exposure level indicator/ CF card writing status
9. Metering mode
10. AF mode
11. AEB

12. Drive mode
13. Monochrome shooting
14. Shots remaining/Shots remaining during WB bracketing/Self-timer countdown/ Bulb exposure time
15. Aperture
16. AF point selection/CF warnings/Error code/ Cleaning image sensor
17. Shutter speed/Busy/ISO speed
18. ISO speed

operational when the camera is on. To read the data in low light conditions, press the LCD Panel Illumination button ☼ above the top left corner of the Panel (indicated by a light bulb icon).

Viewfinder

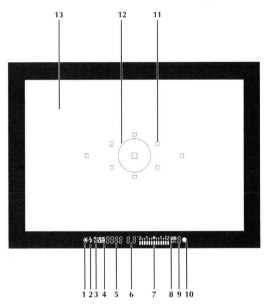

1. *AE lock/AEB in-progress*
 ✱
2. *Flash-ready/Improper FE lock warning* ✦
3. *High-speed sync (FP flash)* ✦ₕ */FE lock/FEB in-progress* ✦*
4. *Flash exposure compensation* 🔲
5. *Shutter speed/FE lock (FEL)/Busy/CF card warnings*

6. *Aperture*
7. *Exposure level indicator*
8. *White balance correction*
9. *Max. Burst*
10. *Focus confirmation light* ●
11. *AF points (Superimposed display)*
12. *Spot metering circle*
13. *Focusing screen*

The Viewfinder

The 5D has an eye-level, reflex viewfinder with a fixed pentaprism. The eyepoint is 20 millimeters, which is good for people with glasses. The viewfinder provides 0.71x magnification and shows 96% of the image captured by the sensor.

Images from the lens are reflected to the viewfinder by a quick return, semi-transparent half-mirror. The mirror lifts for the exposure, then rapidly returns to minimize viewing blackout. The mirror is also dampened so that mirror bounce and vibration are essentially eliminated. Depth of field can be previewed through the viewfinder by using the Depth-of-Field Preview button, near the lens on the lower left front of the camera.

Along the bottom of the viewfinder there is a great deal of data displayed, including exposure information, flash settings, CF card information, white balance correction, and focus confirmation. Only the applicable settings will illuminate. At the center of the viewfinder is a faint circle that represents the spot metering area. The nine selectable autofocus points are arranged roughly in a diamond shape around the circle.

The EOS 5D is supplied with a standard focusing screen (Ee-A). Two accessory screens are available, a grid screen (Ee-D), and a precision focusing screen (Ee-S). All three screens use random micro lens construction to increase viewfinder brightness and aid manual focus. The Ee-A and Ee-D screens are optimized for slower lenses (down to f/5.6). Ee-S screen has finer micro lenses for use with fast lenses (f/2.8 and faster). Each screen has slightly different metering characteristics and Custom Function C.Fn-00 must be set to compensate for this. Use setting 0 for the Ee-A screen, 1 for the Ee-D, and 2 for the Ee-S.

Viewfinder Diopter Adjustment
The viewfinder of the 5D features a built-in diopter adjustment with a range from -3 to +1 dpt. The adjustment knob is just above the eyecup on the right side. Rotate the adjustment knob until the AF points appear sharp. Don't use an object that the camera is focused on to judge the dioptric adjustment. Look at the actual AF points on the viewfinder screen or the information along the bottom of the viewfinder. If you want to shoot without eyeglasses and the dioptric adjustment is not sufficient, Canon makes accessory dioptric lenses that can be added to the eyepiece.

Date/Time

The EOS 5D will record the date and time a photo is taken and include them as part of the image file's metadata. Therefore, you must set this information on the camera if you want it to be recorded accurately. Set the date and time by going to the Set-up menu ⓘⓘ . Turn the Quick Control Dial ⊙ to highlight Date/Time, and then press the Set button ⓢ . Continue to use the ⊙ and the ⓢ to scroll to and set the current month, day, year, and time.

A CR2016 lithium battery is the backup battery for the date and time settings. If the date and time need to be reset after you change the camera's main battery, a new backup battery is needed. You shouldn't need to change this very often. (Canon states that the battery life is about 5 years.) To put in a new CR2016 lithium battery, open the two terminal covers on the left side of the camera. Use a small Philips screwdriver to remove the screw that is closer to the back of the camera. Pull out the battery holder, slide the battery out, and insert a new battery with the negative terminal facing up.

The Sensor

The EOS 5D puts a newly designed, single-plate 12.8 megapixel sensor into a relatively small and lightweight camera. The sensor is described as being full-frame because it measures 1.4 x 0.94 inches (35.8 x 23.9mm), which is approximately the same size as a 35mm frame of film. This larger sensor has several advantages. The maximum resolution of 4368 x 2912 pixels produces image files large enough to print as a double-page spread in a magazine. This larger sensor can fit more pixels without sacrificing pixel pitch. The individual pixel size is a generous 8.2 microns, which helps to minimize image noise especially in the shadows.

The full-frame sensor also eliminates the magnification factor associated with digital SLRs (D-SLRs) that have smaller sensors. All lenses produce the same look as they would

with a conventional SLR camera. This is especially relevant for photographers who use wide-angle lenses.

The anti-aliasing filter consists of an infrared-blocking filter, a primary low-pass filter, a phase plate, and a secondary low-pass filter. This multi-layered filter also functions as the CMOS sensor package's cover glass. Previous camera models use three crystal plates, but the EOS 5D's filter has one independent crystal plate doing double duty as the cover glass. This reduced costs, so Canon was able to design a camera with a full-frame sensor at a more affordable price.

A refined CMOS production process and optimized photodiode construction increase the light-sensitive area of each pixel and improve the sensor's dynamic range. The use of Canon's second-generation, noise reduction circuit minimizes random noise and eliminates fixed-pattern noise. The large microlens array gathers light very efficiently for the photodiodes. A sensor has a wide standard ISO range from 100 to 1600 adjustable in 1/3-stop increments, with additional settings of 50 and 3200.

Cleaning the Sensor

The EOS 5D does allow you to clean the sensor, but there are precautions to be taken. You must do this carefully and gently, indoors, and at your own risk. Before cleaning the sensor, make sure the battery is fully charged or use the AC adapter (ACK-E2). The sensor is very sensitive, so if the gentle cleaning method described below isn't enough, you should send the camera to a Canon Service Center for a thorough cleaning.

To clean the sensor, turn the camera on and go to the Setup menu ❔ . Scroll down using the Quick Control Dial ○ and select Sensor cleaning. Press the Set button (SET) and—assuming your battery is charged—you'll see a screen reminding you to turn off the camera after cleaning the sensor and giving you the choice of Cancel and OK. (If your battery isn't fully charged, a warning message will appear and you will not be able access the cleaning func-

tion.) Select OK and "Cln" will blink on the LCD Panel, the mirror will lock up, and the shutter will open.

Take the lens off and hold the camera so the lens mount is facing down—you want any debris you dislodge to fall out of the camera. Use a bulb-type blower to gently blow any dust or other debris off the bottom of the lens opening first, then off the sensor. Do not use brushes or compressed air because these can damage the sensor's surface. Canon specifically recommends against any cleaning techniques or devices that touch the surface of the imaging sensor. Turn the camera off when done. The mirror and shutter will return to their normal position. Put the lens back on.

To prevent dust from reaching the sensor, never leave the camera body without either a lens or body cap for any length of time. Lenses should be capped when not in use and rear lens caps should always be used on lenses when they are not mounted.

Caution: If the camera powers down during cleaning, the shutter will close and damage to the shutter curtain or image sensor could occur. During cleaning do not turn the camera off, do not open the Card Slot Cover, and do not open the Battery Compartment Cover.

High-capacity Compact-Flash cards are recommended because the EOS 5D's large image files can quickly fill a memory card.

CompactFlash Card

The Canon EOS 5D stores images on CompactFlash (CF) memory cards; it will accept both Type I and II. These cards are a standard in the industry and readily available at most photo and electronics stores. You will need a sizeable card to store the image files created by this camera. Any CF card smaller than 256MB will fill up too quickly, especially if you want to capture uncompressed RAW files.

Most memory cards are very sturdy, durable devices. They are not damaged by airport security x-rays, and they can typically withstand being dropped or even getting wet. However, do not expose them to heat as this will damage them.

To insert the memory card into your camera, first turn the camera off. It's a good idea even though the 5D will automatically shut off when the Card Slot Cover is opened. With the Card Slot Cover open, hold the CF card with the label towards you and the pin contacts directed into the slot. Ease the card into the slot until the gray Card Eject button pops up, and then close the Card Slot Cover. To remove the memory card from your camera, simply open the Card Slot Cover on the right side of the camera and push the Card Eject button. Just be sure that the camera is finished writing to the CF card, otherwise you may corrupt the directory or damage the card, making the files impossible to read.

The camera has three options for numbering the images stored on the card: continuous, auto reset, and manual reset. With continuous, the images are numbered consecutively from 0001 to 9999 even when you change cards. Auto reset will start numbering files at 0001 each time you insert a new card. When manual reset is selected, it creates a new folder and starts numbering new images at 0001. There is no arbitrary advantage to either numbering method. It is a personal preference depending on your workflow needs. Continuous numbering can make it easy to track all the image files taken for a shoot. Resetting numbers will let you organize the images on your various CF cards.

The camera will write images into folders on the CF card in groups of 100. (If you delete images as you shoot, there may not be 100 images in a folder.) Folders are numbered up to 999. At 999, you will get the message "Folder number full" on the LCD Monitor. Once image 9999 is recorded, you will get an "Err CF" message. At that point you have to replace the CF card even if it is not full.

Formatting Your CF Card

Caution: Formatting will erase all images and information stored on the card, including protected images. Be sure to transfer all of the images that you want to save off the card before formatting.

When you buy a new memory card or own one that you've never used with your EOS 5D, it's a good idea to format it. First, make sure there is nothing on the card you want to keep. Then, go to the Set-up menu ⁇ and scroll to Format using the Quick Control Dial ☉ . Press the Set button ⓢⒺⓉ and the Format menu will appear on the LCD Monitor. It will tell what size memory card you have and how much of the card presently contains images. Use the ☉ to select OK, press the ⓢⒺⓉ , and formatting will occur. You will see a screen showing the formatting in progress. Keep in mind that formatting will erase all of the images on the card, even those that are protected!

You should format your CF cards once in a while to keep their data structure organized. However, you should only use your digital camera to format memory cards. A computer uses different file structures than a digital camera, which can make the card unreadable for the camera.

Cleaning the Camera

It is important to keep your camera clean in order to mini-mize the amount of dirt or dust that could reach the sensor. A good kit of cleaning materials should include the follow-ing: a soft camel hair brush to clean off the camera, an anti-static brush and micro-fiber cloth for cleaning the lens, a small rubber bulb (you can get one from a camera store or use an ear syringe) to blow debris off the lens and the cam-era. Also, carry a pack towel for drying the camera in damp conditions (available at outdoor stores).

Always blow and brush debris from the camera before rubbing it with any cloth. For lens cleaning, blow and brush first, then clean with a micro-fiber cloth. If you find there is residue on the lens that is hard to remove, you can use lens cleaning fluid. (Be sure it is made for camera lenses.) Never apply the fluid directly to the lens, as it can seep behind the lens elements and get inside the body of the lens. Apply with a cotton swab or the edge of your micro-fiber cloth. Rub gently to remove the dirt, then buff the lens with a dry sec-tion of the cloth. Replace the cloth in its protective packet to keep it clean. You can wash it in the washing machine (and dry it in the dryer) when it gets dirty.

You don't need to be obsessive about cleaning your cam-era, just remember that a clean camera and lens helps to ensure that you don't have image problems. Dirt and other residue on the camera can get inside when changing lenses, which causes a problem if it ends up on the sensor. Dust on the sensor will show up as small, dark, out-of-focus spots in the photo (most noticeable in light areas, such as sky). You can minimize problems with sensor dust if you turn the cam-era off when changing lenses (to keep from building up a static charge), and keep a body cap on the camera and lens caps on lenses when not in use.

File Formats and In-Camera Processing

The heart of the EOS 5D camera is the DIGIC II Image Processor. Canon has long had exceptionally strong in-camera processing capabilities and this version builds on prior Canon technology. One obvious advantage over earlier Canon processors is size. Previous models used three separate chips. The DIGIC II combines the functionality of these three chips into a single chip allowing for a more compact design.

DIGIC II intelligently translates the image signal as it comes from the sensor, optimizing that signal as it is converted into digital data. New complex processing algorithms and the camera's high-speed buffer allow the DIGIC II to manage signals from the sensor quickly so that the camera response time is dramatically improved. The processing, compression, display, and write times for each image are significantly faster, and the DIGIC II has the added benefit of low power consumption. It is important to understand that this does not affect how quickly the camera can take pictures. Rather, it affects how fast it can transfer images from its buffer to the card. It won't change the shots per second, but it will affect how many images can be taken in succession.

The processor also provides improved image color, enhanced image quality, precision white balance, and accurate metering. Color reproduction of highly saturated, bright objects is better, as is auto white balance, especially at low color temperatures. In addition, false colors and noise—always a challenge with digital capture—have been reduced. The DIGIC II processor gives the 5D the potential to create JPEG files that are superior to unprocessed RAW files, reducing the need for RAW processing.

◁ *Large, fine quality JPEG files are ideal for vacation photos and snapshots. They take up much less memory card space than RAW files and the universal format makes them easy to share.*

File Formats

The Canon EOS 5D can record images in two file formats: JPEG and RAW. From these two file formats you have 13 settings for image-recording quality, consisting of different combinations of format, file size, and compression. You select image-recording quality from the Shooting menu ◘ under Quality.

When you open the Quality menu, you'll see two columns of file choices. Files in the left column are identified by a symbol and a single letter. These are JPEG files of varying compression and size. The symbol depicts the level of compression. The smooth, curved shape ◢ is referred to as Fine and represents a low amount of compression (Fine = better quality). The stair-stepped shape ◢ is referred to as Normal and has a higher amount of compression applied (Normal = lesser quality). File size or resolution is indicated by the letters L, M, and S, which stand for Large (4368 x 2912 pixels), Medium (3168 x 2112 pixels), and Small (2496 x 1664 pixels).

In the column on the right are the RAW file options. The first six choices record both a RAW file and a JPEG file; the seventh choice records only a RAW file. Every RAW option produces an identical RAW file, a 4368 x 2912 pixel image with no compression applied. Only the file size and compression of the JPEG files change for the RAW + JPEG options. Smaller image sizes are handy for certain specialized purposes, but most photographers will shoot the maximum image size using RAW and the highest-quality JPEG setting. After all, the camera's high resolution is what you paid for!

Each choice does influence how many photos can fit on a memory card. Most photographers will be shooting with large memory cards because they will want the space required by high-quality files on this camera. It is impossible to give exact numbers of how many JPEG images will fit on a card because JPEG compresses each file differently

If you are artistically inclined and intend to adjust your photos with image-processing software, capture them using the RAW file format.

depending on the image. For example, a photo with a lot of detail will have a larger file size than an image with a large area of solid color.

It is essential to note that both RAW and JPEG files can give excellent results. RAW files offer flexibility and control for dealing with difficult exposure and lighting situations. JPEG files provide smaller file sizes with faster and easier image processing. Which format will work best for you? The shooting situation and intended use of your images should determine the format you choose.

Setting the File Format

All settings for image-recording quality are selected in the Shooting menu ⬛ under Quality. When you press the Menu button it is the first selection, highlighted right at the top of the menu. Press the Set button ⑤ and the six JPEG settings appear in the left-hand column, the six RAW + JPEG

settings and one RAW setting appear in the right column. Scroll through the two columns using the Quick Control Dial ⊙ and press the Set button ⊛ to choose the setting you want to use.

RAW File Format

RAW image files contain the unprocessed data from the camera's sensor. Any in-camera image processing, such as ISO, white balance, sharpening, and color saturation, is recorded as a separate file and tagged onto the RAW file. This provides "guidelines" for displaying the image on the camera LCD or with an image-processing program, but leaves the image data pure and unaltered. This allows a photographer to make more controlled and refined adjustments in the computer.

RAW files are considered to be a better choice for "professional quality photography." They preserve the original image data and provide more creative control without image degradation. Various effects can be tried without altering the original image data. One disadvantage of the RAW file format is that it is proprietary. Every manufacturer has its own version of the format and as new cameras are developed, so are new variations of the RAW format. Frequent updates to image-processing software are required to ensure compatibility with the latest RAW file formats.

Though RAW is adaptable, you are still limited by the original exposure as well as the tonal and color capabilities of the sensor. Although you have more options to control the look of your images, it is not an excuse to become sloppy in your shooting. Physical camera settings, such as focus, shutter speed, and aperture cannot be changed later. If you do not capture the best possible file, your results will be less than the camera is capable of producing and you will spend too much of your time adjusting images in the computer.

JPEG File Format

JPEG format compresses (or reduces) the size of the image file, allowing more pictures to fit on a memory card. The JPEG algorithms carefully look for redundant data in the file

(such as a large area of a single color) and remove it, while keeping instructions on how to reconstruct the file. JPEG is therefore referred to as a "lossy" compression format because data is discarded to make the file smaller. The computer will rebuild the lost data quite well as long as the level of compression is low. The more an image is compressed, the smaller the resulting file and the lower the image quality.

Then why use JPEG? There are advantages offered by this format. Smaller file sizes mean faster processing speeds, both in-camera and in the computer. Also, you can fit more files on a memory card—a 1GB card will hold approximately 200 Large, Fine Quality JPEG files, but less than 60 RAW files. Also, JPEG is a universal format. It requires no proprietary software to open files, making it ideal for sharing images with friends, family, even clients. For printing snapshots, JPEG files produce excellent results and are much easier to work with. They typically require less post-processing because the camera makes adjustments to the image as it is written to JPEG format. You cannot print RAW files directly from the camera and most in-store kiosks will not read RAW files. JPEG format is the best option for ease and convenience. You can always shoot RAW + JPEG if you think you need additional image control.

Bit Depth

Bit depth is another advantage that RAW files have over JPEG. The 5D captures image data with 12 bits of information for each color channel. (A binary digit or bit is the smallest piece of information that a computer uses. Data of eight bits or higher is required for true photographic color.) A JPEG file has only 8-bit color. In-camera processing discards color information when the image data is converted to this format. RAW files maintain 12-bit color information. (The fact that they contain 12-bit color information can be confusing since this information is put into a file that is actually a 16-bit format.)

Both 8-bit and 16-bit files have the same range from pure white to pure black because that range is influenced only by

the capability of the sensor. If the sensor cannot capture detail in areas that are too bright or too dark, then a RAW file cannot deliver detail any better than a JPEG file. A RAW file has more information between the white and black extremes of the sensor's sensitivity range producing more subtle tonal variations. These are especially noticeable in the darkest and lightest areas of the photo. The benefits of RAW files are apparent for photographers making fine-art prints or processing images for professional applications.

Color Temperature

Color temperature indicates the hue of a specific light source. The standard unit of measure is Kelvin (K). Although it isn't always discernible, different light sources have different color temperatures. Generally, our brains automatically make perceptual adjustments and we see many types of light as white even though they have very different color temperatures. The hue of a specific light source becomes apparent in photographs though. If you use daylight-balanced film indoors, the pictures will have a warm orange color cast caused by the incandescent bulbs in household lamps or lighting fixtures. Daylight-balanced film is made for a 5500K light source, while incandescent bulbs are only about 3000K.

Warm light has a lower color temperature and cold light has a higher color temperature.

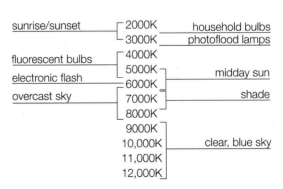

sunrise/sunset	2000K — household bulbs
	3000K — photoflood lamps
fluorescent bulbs	4000K
	5000K
electronic flash	6000K — midday sun
overcast sky	7000K — shade
	8000K
	9000K
	10,000K — clear, blue sky
	11,000K
	12,000K

White Balance

The white balance feature gives digital cameras a big advantage over film. Instead of buying film to match the light source or using filters to adjust color balance, you just set the camera for the type of lighting. While color adjustments can be made in the computer after shooting, especially when shooting RAW, there is a definite benefit to setting white balance properly from the start. With Auto white balance, settings for six specific lighting types, color temperature adjustment in 100K increments, custom white balance, plus white balance compensation and bracketing, the 5D really provides the ability to carefully control color balance in photos. It is well worth the effort to learn when and how to use the different white balance settings so that you can get the best color with the most efficient workflow in all situations (including RAW).

To set the white balance, press the AF•WB button on the top of the camera above the LCD panel. Then, the only settings that will be visible on the LCD panel are the autofocus (lower right corner) and white balance (upper left corner). Rotate the Quick Control Dial ⊙ until the desired white balance icon appears. (If you mistakenly rotate the Main Dial 🗠, you will change the autofocus setting.)

Auto 🖼️

Auto white balance uses the camera's image sensor to analyze the light. Then, the DIGIC II processor compares the readings to similar preset conditions and sets the white balance to make the colors in the scene look natural. AWB is well designed and generally gives acceptable—even good—results, although it covers a limited color temperature range of approximately 3000–7000K. Your image may not have perfect color, but it should be close enough so that only a little adjustment is needed with image-editing software.

AWB can be useful if you don't want the distraction of changing camera settings while you're shooting. You may want to use it if lighting conditions are changing or you're moving quickly from one type of light to another. I highly

Auto white balance generally produces very good results with daylight scenes. ©Marti Saltzman.

recommend you set the camera to AWB when you're done shooting. That way, if you forget to check the white balance when you pick the camera up again, your photos won't have a severe color cast. Basically, you'd use Auto white balance for the same reasons you'd use autoexposure. In fact, when you're shooting in Full Auto mode, Auto white balance is set by default (and is the only option).

While AWB is easy to use and gives good results in a number of situations, it may not be as precise as you'd like. If you change positions or focal lengths as you shoot a scene, colors may not be consistent from picture to picture because the camera is constantly reevaluating the light in each shot. Colors may be dull if there's an absence of pure white in a scene. Also, many photographers find they prefer the control offered by presets and custom settings. This is especially important for creative use of white balance. AWB

may "filter out" a desirable color cast, such as the warmth of a sunset. Use the white balance settings designed for specific lighting conditions or custom white balance to avoid these pitfalls.

Daylight: Approximately 5200K ☀

The color temperature of daylight changes throughout the day and varies with lighting conditions. This setting adjusts the camera to make colors appear natural when shooting a subject in sunlight during the middle hours of the day. Earlier or later in the day, when the sun is lower in the sky and has more red light, the scenes photographed using this setting will appear warmer than normally seen with our eyes. On overcast days, photos taken with this setting may seem a little cold.

Shade: Approximately 7000K 🏠

When subjects are in shadow, they can have a cold or bluish tone if Daylight ☀ white balance is used. This setting warms the light to remove the blue color cast and make colors look natural. (At least that's the ideal—individual situations will affect how effectively the setting performs.) The Shade 🏠 setting is a good one to use anytime you want to warm up a scene, especially when people are included, but you should experiment using this setting for creative results.

Cloudy: Approximately 6000K ☁

The symbol for this setting is a cloud, but its full name is actually the Cloudy/twilight/sunset setting. The setting compensates for the slightly colder light produced by an overcast sky and it maintains the warm tones in scenes photographed at twilight or sunset. This setting adds warmth to images, but not quite to the degree that the Shade 🏠 setting does. Both settings actually work well for sunrise and sunset, producing the warm colors that we expect to see in such photographs. However, the effect of the Cloudy ☁ setting is slightly weaker. For this reason, you may prefer the Cloudy ☁ setting to Shade 🏠 when shooting people. Experiment a bit when using these settings for creative effect and make the final comparisons on the computer.

Tungsten Light: Approximately 3200K ☀

The Tungsten Light ☀ setting is designed to produce natural results with light sources that measure 3200K. This covers incandescent light bulbs, such as quartz halogen and tungsten photo floods. Standard household lighting is a typically little warmer than 3200K. Use this setting for photographing indoors with lamp light and adjust the image color in the computer if necessary. Custom ☟ white balance should be used if color reproduction is crucial. Since this control adds a cold tone to other conditions, it can also be used creatively for this purpose (to make a snow scene bluer, for example).

White Fluorescent Light: Approximately 4000K ☀

Fluorescent lights usually produce a green color cast in photographs. This setting adds magenta to neutralize that effect. You can also use this setting creatively to add a warm pink tone to photos, such as during sunrise or sunset. Fluorescent light is a difficult light source for photography, because the color temperature of fluorescent bulbs is inconsistent. This setting will generally produce acceptable results; any slight color shift can be corrected in the computer. However, if you need precise and accurate color reproduction, use the Custom ☟ white balance setting or try using White Balance Auto Bracketing.

Flash: Approximately 6000K ⚡

Light from a flash tends to be slightly colder than daylight. With the Flash ⚡ setting, the 5D sets white balance for a light source of 6000K versus 5200K for the Daylight ☀ setting. (Flash is essentially the same as the Cloudy ☁ setting; it is simply labeled differently to avoid confusion.) I actually use both the Flash ⚡ and Cloudy ☁ settings frequently. In "daylight" situations they produce an attractive, slightly warm tone that works well for photos of people and outdoor scenes.

Custom ☟

Custom ☟ white balance gives the photographer the greatest amount of control over the white balance setting. It covers the widest color temperature range of any setting from 2000K to 10000K. It is both precise and adaptable in

that it can balance lighting to look neutral with no discernible color cast and it can also be used for creative color control. Although it takes a little extra work to set the Custom ⚑ white balance, the pay off will be more accurate color reproduction in your photos and less time in front of the computer correcting color balance.

To use Custom ⚑ white balance, you must have a white or neutral gray target. This can be standard photographic gray card or even a piece of white paper. Place the white or gray target in the scene you are going to photograph. You want the light hitting the target to be the same as the lighting on your subject. Get close enough so the target fills the spot metering circle in the camera's viewfinder. The image does not need to be in focus; set manual focus if the camera is too close to the target to set autofocus properly. Take the picture and check that exposure is correct. If this image is under- or overexposed, white balance may not be accurate.

When you have a well-exposed image of the target, scroll to Custom WB in the Shooting menu ⚫ and push the Set button ⓈⒺⓉ . The last shot you took will appear in the LCD Monitor. Push the ⓈⒺⓉ again and the camera will use this shot to adjust the white balance. If your camera is not set to Custom white balance, you will see the message "Set WB to ⚑ as a reminder. The white balance adjustments made for the lighting in this scene will stay programmed as the Custom setting until you repeat this process for a new subject.

The Custom ⚑ setting balances the color of the light well in unusual conditions when the type of light or the color temperature is unknown. However, it cannot compensate for different types of light in a scene, such as a subject that is lit by window light with incandescent lights in the background. The Custom ⚑ setting is also beneficial when accurate color is important and the lighting is controlled and consistent, for example when using artificial light in a studio. It can be inefficient and impractical to use Custom ⚑ white balance if lighting conditions are changing frequently.

The Color Temperature setting lets you adjust white balance in 100K increments.

You can also use Custom ⬛ white balance for creative color effects. Instead of using a white or gray card as a target, you would use a colored card or piece of paper. The camera will adjust white balance to give the photo a complementary color cast. If, for example, your target is light blue, the resulting photos will have an amber cast. The camera wants to neutralize the color of the paper, which means the opposite color will become stronger. You can set white balance to have any color cast you want and also vary the intensity of the paper color to adjust the color effect.

Color Temperature ▣
White balance can be set for a specific color temperature from 2800K to 10000K in 100K increments. This offers a wide range of color balance possibilities. It will appeal to film photographers with experience using a color-temperature meter and color-compensation (CC) filters. In addition, it's useful in any situation where you want to warm up or

cool down the image. You have the approximate color temperature settings for specific lighting conditions. Use these as a guide to fine tune image color.

Setting the Color Temperature ▇▇ is a multi-step process; first select it as your white balance mode, then make specific selections with the Shooting menu ⬛ . Press the AF•WB button and turn the Quick Control Dial ◔ to select ▇▇ on the LCD Panel. Press the MENU button and select the Shooting menu ⬛ . Scroll through the menu to Color Temp. and press the Set button ⬛ . Next, turn the Quick Control Dial ◔ to select the desired color temperature and press the Set button to make your choice.

White Balance Correction

The 5D's white balance correction feature offers additional control and fine-tuning of white balance. Photographers accustomed to using color compensating (cc) filters will find this feature quite useful for making slight adjustments to the white balance. It is like having an extensive set of filters in four colors (blue, amber, green, and magenta) each with varied strengths. Each increment of color adjustment is the equivalent of 5 MIREDS of a color-temperature conversion filter.

Note: A MIRED is an approximate measure of the smallest change in color temperature detectable by the human eye. Color temperature can be expressed in MIREDs by dividing one million by the color temperature of the light source. Filters may be referred to by their MIRED shift, which is the change in color temperature they produce converted to MIREDs.

First, select WB SHIFT/BKT in the Shooting menu ⬛ and press the Set button ⬛ . A menu screen will appear with a color-coded graph. The horizontal axis runs from blue (left) to amber (right) and the vertical axis from magenta (bottom) to green (top). Use the Multi-controller ✵ to move the selection point within that graph. In addition to the graph, there is a display labeled "Shift" in the upper right corner of the screen that indicates the color and the amount of white balance shift.

Below the graph the 5D displays a reminder of the camera controls to use. The Multi-controller ✤ moves the selection point around the graph to set the White Balance Shift. The Quick Control Dial ◌ adjusts the White Balance Auto Bracketing, which is also set from this menu screen. The Set button (SET) inputs your settings and returns you to the Shooting menu ⬛ . If you don't press the (SET) , the 5D will not retain any changes you have made. **WB** will appear in the viewfinder and on the LCD panel. Remember to set the correction back to zero when conditions change.

White Balance Auto Bracketing
When you run into a difficult lighting situation and want to maximize your chances of getting the best image color, white balance auto bracketing is an option. Most photographers are familiar with exposure bracketing. A series of exposures is taken at incremental settings as an assurance that one will be ideal. The idea of white balance auto bracketing is similar, but the process is different. You take a single exposure and the camera processes it to give you three different white balance options.

Obviously, this feature can be helpful when shooting in tricky lighting conditions. You'll have three versions of an image from which to choose. Use white balance auto bracketing for creative color choices as well. You want to warm up a portrait, but you don't want the effect to be too strong. Select the Cloudy 🌥 white balance setting, and then use white balance bracketing to set the Amber color shift in small increments. Also, if a scene contains different types of lighting, you can bracket the white balance and create a composite image from the bracketed versions using an image-processing program. Since this feature creates three images from a single exposure, camera or subject movement will not be an issue. This is a big plus when combining images.

First, give some thought to lighting and set the white balance appropriately. You can use white balance auto bracketing with any of the camera's white balance settings. Then, select WB SHIFT/BKT in the Shooting menu ⬛ and press

the Set button ⑤Ⓔⓣ . A menu screen with a color-coded grid will appear on the LCD Monitor. The horizontal axis runs from blue (left) to amber (right) and the vertical axis from magenta (bottom) to green (top). Rotate the Quick Control Dial ◯ to adjust the bracketing increments. If you turn the dial clockwise the adjustment is set along the horizontal axis (blue to amber), counterclockwise sets the adjustment along the vertical axis (green to magenta). The maximum adjustment is +/- 3 levels. You can use white balance shift with white balance auto bracketing. Move the selection points around the graph using the Multi-controller ✣ . For example, to warm up a portrait, you would move all three points to the amber (right) side of the graph. Press the ⑤Ⓔⓣ to input your settings. The white balance icon on the LCD panel will blink to remind you that white balance bracketing is being used.

Note: Custom Function C.Fn-09 changes the bracketing sequence. The default for white balance bracketing records the unbiased image first, and then internally creates the – (more blue or magenta) and + (more amber or green).

RAW Files and White Balance
An advantage of the RAW file format is that many of the camera settings are linked to the file, but do not alter the image data. This includes white balance and it allows you to change the white balance after the shot has been taken by using image-processing software. Because of this, some photographers think that it is not important to select an appropriate white balance when taking photos. The downside to this is that it means more time at the computer making adjustments to files. Therefore, it is a good practice to take a minute and set the white balance on the camera. There are lighting situations that make choosing the best white balance setting difficult, and this is really when the RAW software white balance correction can be a big help.

Picture Styles

Picture Styles follow preset parameters and process images in-camera before saving them to the memory card. These settings are optimized for various subjects and shooting situations, In addition, you can customize the camera's image processing to fulfill your shooting requirements. This can be especially helpful if you are printing image files directly from the camera without using a computer, or when you need to supply a particular type of image to a client.

Picture Styles are accessed through the Shooting menu ◘ . Press the MENU button, scroll with the Quick Control Dial ⊕ to Picture Style then press the Set button ⊕ . To change the parameters for a Picture Style, highlight it on the Picture Style menu screen and press the JUMP button. Use the MENU button to return to the previous screen. Fortunately, the 5D reminds you which buttons perform these functions at the bottom of the menu screen.

The Picture Styles control the degree of in-camera image processing applied to four aspects of an image: Sharpness, Contrast, Color saturation, and Color tone. For Monchrome (black-and-white), choices for Filter effect and Toning effect replace Color saturation and Color tone. Sharpness refers to the amount of sharpening that the camera applies to the image file. Contrast will increase or decrease the contrast of the scene that is captured by the camera. Color saturation influences color richness or intensity. Color tone adjusts the red or yellow tones in a scene. Other colors are affected to a lesser degree. Each style has specific effects by default, but you can change them to suit your own tastes. The default styles with their default settings are:

Standard: This setting is for general picture-taking. It is the default picture style and the only style available with the Full Auto mode. Images have high color saturation and are sharpened slightly to look vivid, sharp, and crisp. The settings for this style are optimal for producing prints with little or no post-processing.

Portrait: This picture style is programmed to produce attractive, healthy skin tones. Magenta, red, and yellow tones are enhanced and sharpness is reduced slightly to de-emphasize blemishes and rough skin. You can further refine this setting by changing the Color Tone parameter.

Landscape: This picture style sets a high degree of sharpness to capture all the details in a landscape. The color saturation is adjusted so that blues and greens are accentuated. This setting is also appropriate for architectural photos.

Neutral: Choose this style if you intend to apply image corrections or alterations with an image-processing program. No sharpening is applied. Saturation and contrast are low to preserve image detail.

Faithful: This style is similiar to neutral with one exception. It is designed to produce accurate colors of subjects photographed under 5200K lighting. The color is adjusted to match this color temperature precisely. No sharpening is applied.

Monochrome: This setting produces black-and-white images or images with a single tone applied. Color data is discarded when this setting is used with JPEG format files, but RAW images retain the color information. Images are sharpened slightly.

User Defined 1-3: This allows you to create custom Picture Styles. You can adjust the four image parameters for your own specific photographic needs.

Monochrome Setting

If you enjoy the look of black-and-white images, the monochrome setting can be fun to use. Of course, these same effects can be applied to images in the computer with an image-processing program. The Contrast and Sharpness parameters are the same adjustments as the other Picture Style settings. Color saturation and Color tone are replaced by Filter effect and Toning effect.

This photo was taken using the Monochrome setting with no filter effect applied.

The Filter effect mimics the look produced by using colored filters with black-and-white film. Color filters are used for black-and-white photography to alter the recorded tonality of specific colors in a scene. A color filter will make similar colors look lighter and complementary colors record darker. Each color choice in the Filter effect menu has the same effect.

N: None, means no filter effects are applied.

Ye: Yellow is a subtle effect that darkens skies and increases contrast slightly.

Or: Orange is next in intensity—stronger than yellow, but not as strong as red. Blues and greens are darkened. Contrast is higher. A good choice for landscapes.

Adding the Yellow filter effect produces a subtle difference. The lemon is a bit lighter and the stripes on the cutting board have more contrast.

R: Red is dramatic. Red flowers or ruddy skin tones record as light gray, while blues and greens become dark. Skies turn quite striking and sunlit scenes gain in contrast. (The sunny areas are warm-toned and the shadows are cool-toned, so the warms get lighter and the cools get darker).

G: Green darkens red, magenta, and orange and lightens greens. Caucasian skin tones look more natural and foliage gets bright and lively in tone.

Toning effect adds a wash of color to the black-and-white image so it looks like a toned black-and-white print. Your choices include N:None, S:Sepia, B:Blue, P:Purple, and G:Green.

The Red filter effect is more pronounced. The radishes are significantly lighter, as is the lemon. The green leaves and the limes are darker.

User Defined Picture Styles

The User Defined Picture Styles allow you save your own customized versions of the preset Picture Styles. To do this, select Picture Style as described above. Then scroll down to User Def. 1, 2, or 3 and press JUMP. This brings up the detail screen to set parameters for the choosen Picture Style. Using the Quick Control Dial ⟳ and Set button ⟨SET⟩ you can select each option and make adjustments. Choose an existing style as a base, then make changes to its parameters. All four parameters that define a particular Picture Style can be changed. When you change the parameter settings, the indicator for the new setting appears in blue while the default setting appears in gray.

Sharpness, Contrast, and Saturation are pretty intuitive. Be wary of pushing Sharpness or Saturation to their maximum intensity (all the way to the right). This can limit the amount of image processing you can do later in the computer.

The Green filter effect lightens the objects that are green and dramatically darkens reds.

(Overprocessing an image can degrade image quality.) Color Tone is specifically optimized for skin tone. Settings to the left of center are more red, to the right are more yellow.

Press the MENU button when you are done to register the new style. On the Picture Style menu, you will see the base style in blue to the right of User Def. 1, 2, or 3.

Downloading New Picture Styles

The Canon web site offers additional Picture Styles for download. They are for specialized situations. For example, there is a Nostalgia setting that lowers the color saturation for all colors except yellow to give photos an aged look and Emerald saturates the green of the sea. These additional Picture Styles are downloaded to your computer and installed by connecting the camera to the computer. The downloaded Picture Style file will fill one of the User Defined Picture Style slots.

Camera Menus and the LCD Monitor

Using the Menus

The Canon EOS 5D, like all digital cameras, includes a great deal of settings that cannot be programmed for use by buttons and dials on the camera. Digital cameras bring a whole range of controls that were never possible in a film camera. Few photographers use all of them, but all of them have uses for at least some photographers. To get these controls onto the camera, designers must include them in menus that can be displayed on the camera LCD. The large 2.5-inch menu of the 5D offers a great benefit for menus because it makes them so much easier to read.

While most controls on the 5D menus will be familiar to digital photographers, Canon has made an effort to make them more readable and user-oriented. Plus there are some new controls unique to the 5D. In addition, the 5D menus can be set to any of 15 different languages.

Navigating the Menus

All menu controls, or items, are grouped into three categories, based on their use. These categories, intuitively named in order of appearance within the menu system, are Shooting 📷 , Playback ▶ , and Set-up 🔧 . To make them easier to follow, they are also color-coded: red for Shooting, blue for Playback and yellow for Set-up. You gain access to the

◄ *Set Auto rotate under the Set-up menu to view vertical images without having to turn the camera sideways. This setting must be selected before the image is taken.*

5D's menu screen whenever you push the MENU button, which is located on the back of the camera next to the top left corner of the LCD Monitor.

At this point, the Shooting menu ⬛ will appear. Move from category to category in one of two ways: push the JUMP button (also on back of camera to left of LCD Monitor) to move immediately to the first item in the next category in order (Shooting-Playback-Setup), or scroll down the items within any category to the bottom and the menu items will automatically roll over to the next category.

These category menus are designated by their icon at the top of the menu screen on the LCD Monitor. You actually see two icons; one at the top left of the screen for the category presently in use, and the next category's icon at the top right. Once in a menu category, rotate the Quick Control Dial ⊙ to select desired items and sub items, and press the Set button ⊕ to confirm, or lock-in, these item choices. You can also use the Main Dial ⊜ (by the shutter release button) to move through the menu items. To get out of the menus, you can press the MENU button, but it is just as easy and probably more efficient from a shooting standpoint to press the shutter release slightly.

⬛ Shooting Menu

For items that obviously affect actual photography, this red-coded menu includes nine choices:
• Quality (set image size and resolution, plus RAW)
• Beep (signal for controls on or off)
• Shoot w/o card (allows you to test the camera when no memory card is in it)
• AEB (auto exposure bracketing in 1/3 stop increments)
• WB SHIFT/BKT (for bracketing and shifting white balance in nine levels)
• Custom WB (manually set white balance)
• Color temp. (manually set color temperature)
• Color space (sRGB or Adobe RGB)
• Picture style (set pre-programmed or custom profiles for processing images in-camera)

Note: Not all menu items will display when the camera is in the Full Auto mode.

▶ Playback Menu

Offers seven choices used when viewing images on the LCD Monitor. This blue-coded menu includes:

- Protect images (allows you to prevent images from being erased unless the card is formatted)
- Rotate (rotate image so vertical will display vertically)
- Print Order (creates instructions for images to be printed DPOF)
- Auto Play (automatic slide show on LCD Monitor changes image every 3 seconds)
- Review time (how long image stays on LCD Monitor after shot)
- AF Points (lets you turn on or off their display in the viewfinder)
- Histogram (lets you choose between Bright—or luminosity—and RGB histograms)

⚙ Set-Up Menu

This menu is coded yellow. It offers 16 selections to make before shooting.

- Auto power off (controls when the camera turns itself off when it is not used for a certain time)
- Auto rotate (affects how verticals are displayed in the LCD)
- LCD brightness (choose from five levels)
- Date/Time
- File numbering options (three options to affect how files are numbered by the camera)
- Select folder (lets you create and select folders on the memory card)
- Language (15 options)
- Video system (for playback of images on a TV—NTSC or PAL)
- Communication (for setting up communication with a printer or computer)
- Format (very important, used to initialize and erase the card)

Image playback on the LCD Monitor is one of the great benefits of digital photography. Check exposure, focus, white balance, and composition immediately after an image is taken and make corrections on-site.

- Custom Functions (C.Fn) (additional custom functions for controlling the camera)
- Clear settings (make settings go back to default)
- Register camera settings (registers settings to the camera's memory for use with the C mode)
- Sensor cleaning (use when cleaning sensor)
- Image transfer (LAN) settings (only used when wireless transmitter is attached to camera)
- Firmware Ver. (used when updating camera's operating system or firmware)

Understanding the menu system is necessary in order to gain full benefit from using the LCD Monitor and the Custom Functions. Most of the common digital camera shooting choices, such as Quality settings and AEB are covered in more detail elsewhere in the book.

The LCD Monitor

The LCD monitor is one of the most useful tools available when shooting digital, giving immediate access to your images. You can set your camera so that the image appears for review on the LCD monitor directly after shooting the picture. It's better than a Polaroid print! However, the EOS 5D is not a live monitor like that seen on compact or point-and-shoot digital cameras. The standard D-SLR uses a mirror to direct the light from the lens to the viewfinder so that the sensor is not active until the exposure (and so cannot send an image to the LCD). At exposure, the mirror pops up so the sensor can capture an image from the lens.

The 5D's 2.5-inch color LCD Monitor is a great improvement over earlier digital camera monitors. It is significantly bigger than the old standard of 1.8-inches and Canon has made improvements to make it more readable at all angles and even in bright light. You can adjust its brightness in the Set-up Menu ﹖ (select LCD Brightness and use the Quick Control Dial ○ and Set button ⑤ᴇᴛ to adjust the brightness level and confirm), but this may change the monitor in such a way that you will find the image harder to evaluate. The easiest thing to do in order to read the LCD better is shade the monitor in bright light by using your hand, a hat, or your body to block the sun.

LCD Image Review

The 5D's LCD Monitor is used strictly for review and editing. You can choose to instantly review the image you have just shot, and you can also look at all of the images you have stored on your CF card. Most photographers like the instant feedback of reviewing their images because it gives a confirmation that the picture is okay.

You need to set the length of time needed to review the images you have just captured. It is frustrating to be examining a picture and have it turn off before you are done. You can set the duration from among a several choices that include 2 sec, 4 sec, 8 sec, or Hold, all controlled by the

Review time selection in the Playback menu ▶ (color code Blue). You also use this menu item to activate the Off option, which saves power by turning off the LCD Monitor, but does not allow you to review the images.

A setting of 2 sec is a bit short. You can't really evaluate anything in that time other than you got a picture. I recommend 8 sec. You can always turn the review off sooner by pressing the Shutter button. The Hold setting is good if you like to study your photos, because the image for review remains on the LCD Monitor until you press the Shutter button. But be careful, it is easy to forget to turn off the monitor when using this selection, in which case your batteries will wear down.

Note: There is a trick not detailed in the camera manual that lets you hold the image even when the duration is not set to Hold. As the image appears for review, press the trash icon 🗑 (normally used for erasing) located below the left corner of the LCD Monitor on the back of the camera. This will leave the image on as long as you want. Ignore the OK and ALL commands (you are not trying to erase the image yet). Press the Shutter button to turn the review image off.

Playback
Reviewing images on the LCD Monitor is an important benefit of digital cameras. To see not only your most immediate shot, but also any (or all) of the photos you have stored on the CF card, press the Playback button ▶ on the back of the camera to the left of the LCD Monitor. The last image you captured will show on the LCD Monitor. You then move from photo to photo by rotating the Quick Control Dial ◌ , either counterclockwise to view images in a sequence from most recent to first captured, or clockwise to view from first shot to most recent.

Note: Buttons and other controls on the camera with blue-colored words or icons refer to playback functions.

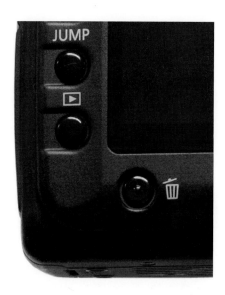

The Playback button is located to the left of the LCD Monitor below the JUMP button.

With the 5D, you can display the review or playback image in three different forms on the LCD by progressively pushing the INFO button, also found on the back of the camera to the left of the LCD Monitor:

1. Display with basic information. The image for review covers the entire LCD screen and includes superimposed data for folder number, image number, number of shots on the CF card, shutter speed, and aperture.

2. Display with full shooting information. A thumbnail of the image is shown with a histogram and expanded data about how the image was shot (such as the date/time, white balance, ISO speed, image recording quality, exposure, and more); this can be very useful for checking what settings are working for you. The thumbnail also includes a Highlight Alert function that blinks where areas are overexposed.

3. Image only display. This shows only the photo with no additional information. The image again covers the whole LCD Monitor, but only the image appears.

Pressing the Shutter button halfway will stop playback by turning the LCD Monitor off, making the 5D ready to shoot again. You can also stop the playback and turn the LCD Monitor off by pressing the Playback button ▶ .

Automatic Image Rotation
Included in the 5D is an option to automatically rotate vertical images during review or playback so they appear up-and-down rather than sideways in the LCD Monitor when the camera is held in a horizontal position. To select this command, called Auto rotate, go to the Set-up menu ⚙ and use the Quick Control Dial ○ and Set button ⑤ . Then choose On again using the ○ and ⑤ . To rotate any image later, you need to choose Rotate in the Playback menu ▶ .

This feature makes amateurs comfortable, but is not a very professional feature. Sure, the image is upright and you don't have to rotate the camera to view it. The problem is the size of the image. To get that vertical image to fit in the horizontal frame of the LCD Monitor, the picture has to be reduced considerably and becomes harder to see. I like keeping Auto rotate off so the largest image possible shows up in the Monitor, even if I do have to rotate the camera to see it properly.

Magnifying the Image
You can make the image larger on the LCD Monitor by factors of 1.5x to 10x. This feature can be beneficial in helping to evaluate sharpness and exposure details. Press the Enlarge button ⊕ (located on back of camera in top right corner—marked by a blue magnifier with plus sign) repeatedly to progressively magnify the image. Press the Reduce button ▦·⊖ (marked by a blue magnifier with minus sign), located to immediate left of the Enlarge button ⊕ , to shrink the magnification. You quickly return to full size by pushing the Playback button ▶ .

Use the Multi-controller ✲ to scroll around the magnified image in order to look at different sections of the picture. The Quick Control Dial ◯ will move from one image to another at the same magnified view so you can compare sharpness at a particular detail, for example.

Creating and Selecting Image Folders

It can be useful to create and use unique folders on your memory card to keep your photos as you shoot. You can create simple folders in camera or use your computer to create special folders with unique names. Having multiple folders allows you to keep different sorts of images separated, such as people photos in one folder and landscapes in another as you are traveling.

If this seems like too much work, you don't have to ever create a new folder on your own as the camera will create them based on new memory cards and after a certain number of photos have been taken. However, if you want to create a folder, it is fairly easy to do. Go to the Set-up menu 🔧 and navigate to the Select folder with the Quick Control Dial ◯ and press the Set button (SET) to choose it. Use the dial again to go to the Create folder option and press (SET). The Create folder screen now appears. Select OK with the ◯ , press (SET) and a new folder will be created (at this point you have no choice over naming, but you can create a lot of folders, up to 900). The folder will be labeled with the left numbers along with EOS5D, such as 102EOS5D.

To select a folder, you follow the same basic directions, but at the Select folder screen, you will now have choices of folders, besides the Create folder option. Select the folder you need and press (SET). Images will now be filed into that folder as you shoot. You can see how many images are in each folder with the number to the right of the folder label.

You can create unique folders in your computer. To do this, open your memory card in the computer (it is easiest to use a memory card reader). Create a new folder and name it DCIM. Then open that folder and create multiple new fold-

ers that meet your needs. You must name each folder with a three-digit number from 100-999 followed by five letters or letters plus underscore. The letters can be upper or lower case. Names like 101John and 102JK_b work. The numbers cannot be duplicated on a given memory card (e.g., 201abcd and 201acde can't be used) and no spaces are permitted in the name or the camera will not recognize the folder. You can use letters to identify subjects, photographers using a single camera, projects and so forth. These names will then show up on the Select folder screen.

File Numbering for Images
Image files on your memory card are automatically numbered from 0001 to 9999. However, the EOS 5D gives you several options as to how these numbers are applied to the images. Changing numbering can be useful if you are working from multiple memory cards and want to ensure the image file names are distinct. You have three numbering choices: Continuous, Auto reset, and Manual reset. These are all selected in the Set-up menu 🍴 under File numbering after navigating there with the Quick Control Dial ⊙ and the Set button (SET) .

Continuous file numbering keeps numbers going in sequence regardless if you change the memory card. This ensures that your numbers are different as they come into the computer from a particular shoot. If you put a memory card into the camera with files already on it, numbering will start as the next higher number from the highest number on the existing images.

Auto reset will make the numbers change and go back to 0001 every time you insert a new memory card. Some photographers like this because it allows them to download and organize images in a similar way even though they come from different cards. Manual reset is, as it sounds, a way for you to force the camera to reset its image numbering. This choice also creates a new folder and numbering will continue based on whether Continuous or Auto reset had been set before choosing Manual reset.

One way to organize your photos is with Manual reset under File numbering in the Set-up menu. As you move from scene to scene, use this setting to create a new folder. Numbering starts at 0001 for each batch of photos. ©Marti Saltzman.

One curious thing to know about numbering with the 5D is that if you reach 9999, the LCD panel and viewfinder will display this warning, FuLL. At this point, you cannot record any new images to that card, even if it has barely been used. You have to go to a new memory card. If you know you are reaching high numbers with your camera, you may want to be sure you use Manual reset before you do any important shooting.

Image Protection
This is an underused and underappreciated feature of a digital camera that can really help you. The most important function of Image Protection is to allow you to go through your pictures one at a time on the LCD Monitor, choosing which ones to keep, or "protect", meaning all the rest can be discarded by erasing them all at once.

Protection is very easy to use: go to the Playback menu ▶ and select Protect. Press the Set button (SET) and one image will appear in the LCD Monitor with a symbol of a key and the word SET appearing at the top left of the photo. Next go through your photos one by one using the Quick Control Dial ☉ and push the (SET) for every one that is a potential "keeper." An icon showing a little key will now show at the bottom of the image.

Once you have chosen the protected images, erase all the rest by selecting All on the Erase screen (see below). You have now done a quick edit, giving you fewer photos to deal with after downloading to the computer. There is often downtime when shooting, so use it to go through your photos to edit by "protecting" key shots.

Erasing Images

The 5D's process for erasing photos from the memory card is the same as that used by most digital cameras. When an image is displayed on the LCD Monitor, push the Erase button 🗑 located below the left corner of the LCD Monitor. A screen will appear with three options for erasing the image. Turn the Quick Control Dial ☉ to highlight the appropriate choice. The first option is Cancel, which will cancel this function. Next is Erase, which is the most commonly use function here and will erase the image being displayed. And last is All, to use if you want to delete all unprotected images on the CF card. You can erase images during playback or right after exposure when an image appears in review.

Note: Once an image is erased, it is gone for good (though there is software available that may be able to recover it if you don't take any more photos that might record over the original files). Make sure you no longer want an image before making the decision to erase it.

Format

Another way of erasing images from the memory card is to format the card. This removes all images and all menu structures from the card. It essentially cleans out the card of all information.

TV Playback

If you have a group of people who need to see your photos, and you have access to a television with standard RCA input connectors, you can display images on the TV from the memory card.

First, go to the Set-up menu ᴵᵀ and select the option for Video system. Then, if you are in the US or Canada, be sure to choose NTSC. (For many other parts of the world, you will need to select PAL). Make sure both the camera and television are turned off and connect the camera to the TV using the cables supplied with the camera. Plug into the Video Out connector on the camera and Video In on the television. Turn the TV on, then the camera. Now press the Playback button ▶ and the image will appear on the TV (but not on the back of the camera). Some TV's will cut off edges of the image.

Customizing Your Camera

Like most sophisticated digital cameras, the Canon EOS 5D can be customized to fit the unique needs and personality of a photographer. As you select exposure modes, type of metering, focus choice, drive speed, and so forth, you do tailor the camera to your specific needs. If you use certain settings frequently, you can have the camera remember them. The 5D lets you "register" or save those settings, which are then accessible with the Mode Dial's C setting.

This can be a very handy control. Say you are doing some specific close-up work and need to photograph a portrait with quite different settings in the middle of the shoot. By registering the camera's settings for the close-up photography, you can instantly go back to them by going to the C mode. Nearly all camera settings can be remembered through the registration process.

You can create a "custom program" on the 5D by setting all the shooting and menu options as desired and using Register camera settings in the Set-up menu to save them.

The process is fairly simple. Set your camera with the desired shooting mode, AF mode and so forth. Then go to the Set-up menu ¶¶ and to "Register camera settings." Use the Quick Control Dial ☉ to select OK and press the Set button ⑤ᴇᴛ . The camera will now duplicate the present camera settings any time you choose C. You can still change the drive mode and menu settings when under C, but the camera won't remember those changes unless you go through the procedure again.

Register camera settings will remember these shooting settings: shooting mode and camera settings for it, AF mode, AF point selection, metering mode, ISO speed, drive mode, exposure compensation, flash exposure compensation, and white balance. It will also remember these menu settings: Quality, Beep, Shoot w/card/ AEB, WB Shift/BKT, Custom WB, Color temp, Color space, Picture style, Review time, AF points, Histogram, Auto power off, Auto rotate, LCD brightness, File numbering (method), and Custom Functions.

If you don't remember what settings are included in your C mode, you can always check by setting the Mode Dial to C and pressing the INFO button to the left of the LCD. You can revert the C mode to the default settings by using the Clear settings command in the Set-up menu ¶† , but I caution you on doing that because it will reset everything on the camera, including things like Auto rotate and Review time, which may have preferred settings and frustrate you if they don't appear as you expect.

Custom Functions
In addition to the C mode, you can further adapt the 5D with customization and personalization to help the camera better fit your personality and style of photography. This is done through the Custom Functions menu. Some photographers never use these settings, while others use them all the time. The camera will not take better photos by changing these settings, but Custom Functions may make the camera easier for you to use.

The 5D has 21 different built-in Custom Functions (C.Fn), numbered 00-20. They are found in the Set-up menu ¶† under the selection for Custom Functions (C.Fn). Use the Quick Control Dial ☉ to get to the C.Fn. option you want (a helpful description of the control's function appears on the LCD Monitor as each is selected). Use the Set button ⒮ⓔⓣ and the ☉ to choose the desired custom function. Press MENU to exit this part of the menus and return to the ¶† . When you change a Custom Function from the default, a small C.Fn will appear on the top LCD panel (except for C.Fn-00). Here is a brief summary and commentary on the various Custom Functions.

C.Fn-00 Focusing Screen

The EOS 5D does allow for changing the focusing screen to meet special needs of the photographer. This function sets the camera properly so that exposure compensation works with each specific screen. It is not included in Register camera settings.

0. Ee-A (default)—This is for the standard Ee-A focusing screen that comes with the camera.
1. Ee-D—This screen is the same as Ee-A but has a grid for easier alignment of horizontal and vertical lines.
3. Ee-S—This is a specialized matte screen for precision manual focus. It does make the viewfinder darker than Ee-A or Ee-D.

C.Fn-01 SET function when shooting

This setting assigns new options for using the Set button (SET).

0. Default—the Set button (SET) works normally, acting like an OK button for menus.
1. Change quality—allows you to press the (SET) and go directly to recording quality, changing it with the Quick Control Dial (○). (This is useful if you want the ability to quickly change from RAW to JPEG). The settings appear in the LCD Panel.
2. Change Picture Style—the (SET) will take you directly to the Picture Style selection screen in the menus.
3. Menu display— (SET) acts like the MENU button (some people find this more convenient).
4. Image replay—the (SET) acts like the Playback ▶ .

C.Fn-02 Long exp. noise reduction

This is a simple on/off switch, which adds noise reduction for long exposures.

0. Off—default
1. Auto noise reduction—for exposures of 1 sec. or longer, the camera looks for noise and automatically applies

noise reduction if found. However, this does add process-ing time, which may slow the camera; while it is in progress, image playback and menu use is not possible.

2. On—noise reduction is applied to all exposures of 1 sec. or longer even if noise is very low and would not be detected under setting 1. This means every long exposure will likely slow down the camera as it processes it.

C.Fn-03 Flash sync speed in Av mode

This setting controls the camera-selected flash-sync speed in Av mode.

0. Auto (default)—the camera varies the shutter speed to match the ambient light conditions.
1. 1/200 sec. fixed—the camera always uses 1/200 sec. (This custom function doesn't seem to be particularly useful, since using Manual exposure (M) mode at 1/250 then changing f/stop would give you the same feature without going through the menu).

C.Fn-04 Shutter/AE Lock button

This controls the functions of the shutter button and AE Lock button ✱ .

0. AF/AE lock (default)—focus and exposure are locked when the Shutter button is depressed halfway; exposure is locked with the AE Lock button ✱ .
1. AE lock/AF—autofocus is initiated and locked with the ✱ . The Shutter button locks exposure when depressed halfway.
2. AF/AF lock, no AE lock—pressing the ✱ temporarily interrupts and locks focus in AI Servo AF mode. The exposure is set when the shutter releases. (This prevents focus from being thrown off if an object passes briefly in front of the camera.)
3. AE/AF, no AE lock—lets you start and stop AI Servo AF by pushing the ✱ . Exposure is set when the shutter releases.

C.Fn-05 AF-assist beam

This controls the AF-assist beam on a dedicated EOS Speedlite.

0. Emit (default)—the AF-assist beam is emitted whenever appropriate.
1. Does not emit—this cancels the AF-assist beam, which can be useful in sensitive, low-light situations.

C.Fn-06 Exposure level increments

This sets the size of incremental steps for shutter speeds, apertures, exposure compensation, and autoexposure bracketing (AEB).

0. Default—the increment is 1/3 stop
1. 1/2 stop

C.Fn-07 Flash firing

This is used to disable the firing of a flash in sensitive situations.

0. Fires (default)—flash fires whenever appropriate
1. Does not fire—flash will not fire under any circumstances.

C.Fn-08 ISO Expansion

This expands the ISO range of the camera to 3200.

0. Off (default)— ISO expansion is turned off.
1. On—this expands the ISO settings to include 50 and 3200. "L" is the setting for ISO 50. "H" is the setting for ISO 3200.

C.Fn-09 Bracket sequence/Auto cancel

This allows you to set the order of bracketing for exposures and white balance or cancel bracketing.

0. 0, -, +/Enable (default order with auto cancel)— exposures will be made in this order: metered exposure, underexposure, and overexposure, with auto cancellation (meaning bracketing will be canceled if you change the

lens, turn the camera off, replace the battery or the CF card). White balance will be the set WB, then cooler (more blue) and warmer (more amber) or more magenta and green (which bias is dependent on how you set it up—see page 60 for more on WB bracketing).

1. 0, -, +/Disable (default order without auto cancel)—exposures will be made in the same order as above but there is no auto cancellation.

2. -, 0, +/Enable (optional order with auto cancel)—exposures will be made in this order: underexposure, metered exposure, and overexposure, with auto cancellation. White balance will be cooler (more blue), the set WB and warmer (more amber), or more magenta, the set WB and more green.

3. -, 0, +/Disable (optional order but no auto cancel)—this is the same as 2 but with no auto cancellation.

C.Fn-10 Superimposed display
This changes how the AF points appear in the viewfinder.

0. On (default)—this illuminates or highlights the appropriate AF point when the camera locks focus (or points, depending on the AF mode).

1. Off—turns off the illumination. Some photographers find the illuminated point distracting. The AF point will still light when you select it manually.

C.Fn-11 Menu button display position
This function changes how the menus are presented when you press the MENU button.

0. Previous (top if power off)—this default setting shows the last menu item you looked at ("previous"), but will go to the top of the menu (Quality) if the switch is turned off, the battery is replaced, or the CF card is replaced.

1. Previous—this does the same thing as above, but it always goes to the last menu item even if the camera is turned off.

2. Top—this always displays the top menu screen (Quality).

C.Fn-12 Mirror lockup

This Custom Function turns mirror lockup on or off.

0. Disable (default)—the mirror functions normally
1. Enabled—the mirror will move up and lock in position with the first push of the Shutter button (press fully). With the second full pressing of the shutter button, the camera will then take the picture and the mirror will return to its original position. This can minimize camera movement for critical exposures using long telephoto lenses. After 30 seconds, this setting automatically cancels.

C.Fn-13 AF point selection method

This control changes the how AF points are selected manually.

0. Normal (default)—the AF point is selected using the AF point selection button and the Multi-controller ✧ .
1. Multi-controller ✧ direct—this setting lets you select AF point using just the ✧ . The AF point selection button is used to set the camera back to auto AF point selection.
2. Quick Control ◌ direct—this lets you use the Quick Control Dial ◌ for AF point selection. However, you must push the AF point selection button to use the ◌ for exposure compensation.

C.Fn-14 E-TTL II

This is a simple control that lets you choose a different way of metering electronic flash.

0. Evaluative (default)—this uses fully automatic Evaluative metering ⊡ for all conditions.
1. Average—this setting averages the flash exposure readings over the entire area covered by the flash.

C.Fn-15 Shutter curtain sync

This is a creative control that determines how motion blurs are rendered in flash photography.

0. 1st curtain sync (default)—this is the standard flash sync for most cameras (also called front-curtain sync). The flash goes off at the beginning of the exposure, as soon as the shutter curtains fully open to expose the whole sensor. At slow shutter speeds, the flash will create a sharp image and motion blur is registered after the flash. With moving subjects, this results in a blur or light trail that appears to be in front of the sharp flash-exposed subject (because the movement forward is after the flash). Such a blur is not natural looking.

1. 2nd curtain sync—the flash fires at the end of the exposure (also called rear-curtain sync), just before the second shutter curtain closes. At slow shutter speeds, this results in an ambient light motion blur that looks natural because it trails behind a moving, sharp flash-exposed subject. Don't be alarmed when using this that a flash occurs at the beginning of the sequence—this is a pre-flash used for setting exposure.

C.Fn-16 Safety shift in Av or Tv

You can allow the camera to smartly shift exposure when shooting in Av or Tv modes when the brightness of the scene exceeds the camera's capabilities at the chosen aperture or shutter speed.

0. Disable (default)—this locks in the chosen f/stop for Av, or the shutter speed for Tv, regardless of conditions.

1. Enable— this choice lets the camera shift f/stop or shutter speed to get a good exposure automatically.

C.Fn-17 AF point activation area

This changes how AI SERVO AF works in using added AF assist points.

0. Standard (default)—no added points.

1. Expanded—when the center AF point is selected, six invisible AF assist points within the spot metering circle are activated. These give seven points to help track an erratically moving subject.

C.Fn-18 LCD displ -> Return to shoot

This changes how the camera returns to the shooting mode when you are playing back images on the LCD monitor or using the menus.

0. With Shutter Button only (default)—during playback of images, you return to shooting mode by pressing the shutter button.
1. Also with ✻ etc.—with this function selected, you return to shooting by pushing almost any button (✻ , AF-WB, AF selection point button, meter type button, DRIVE-ISO, illumination, or depth of field). This also lets you enlarge or reduce the image magnification during image review by holding down the print button and the magnifying buttons. Easy Printing will not work.

C.Fn-19 Lens AF stop button function

This is a specialized function to modify how autofocus is controlled by certain telephotos with an AF stop button. If your lens does not have this button, this function is meaningless.

0. AF stop (default)—this is simply standard autofocus, but you can stop autofocus by pushing the AF stop button.
1. AF start—autofocus operates only when the AF Stop button on the lens is pressed. AF operation with the camera itself will be disabled while the button is pressed.
2. AE lock while metering—the AF Stop button locks exposure if it is pressed while metering is still active. This selection is great if you want to meter and focus a scene separately.
3. AF point: M -> Auto/Auto -> ctr—holding down the AF Stop button will switch the camera from manual AF point selection to automatic AF point selection, but only while you hold it down.
4. One shot <-> AI servo—this choice enables the AF Stop button to switch the camera from One-Shot AF mode to AI Servo AF mode as long as the button is held down.
5. IS start—with the lens' IS switch turned on, the Image Stabilizer only operates when you press the AF Stop button.

The camera's Custom Functions offer additional controls to set the camera to match your subject matter and your shooting style.
©Marti Saltzman.

C.Fn- 20 Add original decision data

This very specialized setting is used by police and other law organizations.

0. Off (default)
1. On—this turns the feature on so that data for verifying that images are original is added to the image file. To read this data, you need to use the optional Data Verification Kit DVK-E2.

Camera Operation Modes

The 5D is a highly sophisticated and feature-laden digital camera. The innovation, thought, and technology that have been placed in this camera become evident as soon as you begin to operate its various systems and utilize its many functions. From its ability to focus on moving subjects to its advanced metering capabilities, the 5D offers a number of options to help you take extraordinary photographs.

Exposure

No matter what technology is used to create a photo, it is always preferable to have the best possible exposure. Digital photography is no exception. A properly exposed digital file is one in which the right amount of light has reached the camera's sensor and produces an image that corresponds to the scene, or to the photographer's interpretation of the scene. This applies to color reproduction, as well as tonal values and subject contrast.

ISO
When shooting with film, setting the ISO provides the meter with information on the film's sensitivity to light, so that it can determine the exposure required to record the image. The ISO setting on a digital camera adjusts the sensitivity of the sensor to be comparable to film speed. (This change in sensitivity involves amplifying the electronic signal that creates the image.) Since sensitivity to light is easily adjustable using a digital SLR, and since the 5D offers clean images with minimal to no noise at any standard setting, ISO is a control to use freely so you can adapt rapidly to changing light conditions.

➪ *White it's true you can make adjustments to your photos using image-processing software, you'll always get better results if you start with a properly exposed image. ©Marti Saltzman.*

The 5D offers ISO sensitivity settings of 100 – 1600 in 1/3-stop increments with additional settings of ISO 50 and 3200. Low ISO settings give the least amount of noise and the best color. However, they require more light for proper exposure. Traditionally, film increases in grain and decrease in sharpness with increased ISO. Some increase in noise (the digital equivalent of grain) will be noticed as the higher ISO settings are used, but it is minimal until the settings of 800 or higher are chosen. Little change in sharpness will be seen. Even the settings of 800 and 1600 offer very good results. This opens your digital photography to new possibilities for using slow lenses (lenses with smaller maximum lens openings, which are usually physically smaller as well) and in shooting with natural light.

Choose an ISO based on the type of subject and the lighting conditions. ISO 100 is a good choice to capture detail in images of nature, landscape, and architecture. Use ISO 400 when faster shutter speeds are needed and for shooting with a long lens. An ISO of 800 or 1600 is ideal for low-light conditions.

Setting the ISO: To set the ISO, press the DRIVE•ISO button located on the top of the camera in front of the LCD Panel. Then turn the Quick Control Dial ☾ until you see the desired speed displayed in the LCD Panel. The additional low and high ISO settings of 50 and 3200 are accessed through Custom Function 08. With C.Fn-08 set to ON, 50 and 3200 become additional ISO choices. However, L and H appear on the LCD Panel instead of 50 and 3200 respectively.

Metering

In order to produce the proper exposure, the camera's metering system has to evaluate the light. However, even today there is no light meter that will produce a perfect exposure in every situation. Because different details of the subject reflect light in different amounts, the 5D's metering system has been designed with microprocessors and special sensors that give the system optimum flexibility and accuracy in determining exposure.

Evaluative metering measures and compares readings from 35 separate image zones to set exposure. ©Marti Saltzman.

It is difficult to capture perfect exposures when shooting extremely dark or light subjects, subjects with unusual reflectance, or backlit subjects. Because the meter theoretically bases its analysis of light on an average gray scene, when subjects or the scene differ greatly from average gray, the meter will tend to overexpose or underexpose them. This is why the 5D offers various options for metering a scene. Also, you can check the image on the LCD Monitor and make adjustments as needed.

The camera offers four metering modes: Evaluative, Partial, Spot, and Center-Weighted Average. To select the metering mode, press the ⊙·⚡ button on top of the camera and then rotate the Main dial ⌂ . The symbol or icon for the type of metering in use appears on the LCD Panel.

Evaluative Metering 　⬜ : The 5D's Evaluative metering system divides the image area into 35 zones, compares them, and then uses advanced algorithms to determine exposure. Basically, the system evaluates and compares all of the metering zones across the image, noting things like the subject's position in the viewfinder (based on focus points and contrast), brightness of the subject compared to the rest of the image, backlighting, and much more. These zones come from a grid of carefully designed metering areas that cover the frame.

As with all Canon EOS cameras, the 5D's Evaluative metering system is linked to autofocus. The camera actually notes which autofocus point is active and emphasizes the corresponding metering zones in its evaluation of the overall exposure. If the system detects a significant difference between the main point of focus and the different areas that surround this point, the camera automatically applies exposure compensation (it assumes the scene includes a backlit or spot-lit subject). However, if the area around the focus point is very bright or dark, the metering can be thrown off and the camera may underexpose or overexpose the image.

The main advantage of Evaluative metering over Partial and Center-weighted metering is that the exposure is biased toward the active AF point, rather than just concentrating on the center of the picture. Plus, Evaluative metering is the only metering mode that will automatically apply exposure compensation based on comparative analysis of the scene.

Note: With Evaluative metering, exposure values are locked after autofocus has been achieved as long as the shutter release button is partially depressed. However, if the lens is set for manual focus, meter readings are not locked by holding down the shutter release button. You must use the AE Lock button in that case.

Partial Metering 　⬜ : Partial metering utilizes the exposure zones at the center of the viewfinder, reading approximately 8% of the frame. This allows the photographer to

selectively meter portions of a scene and compare the readings in order to select the proper exposure. This can be an extremely accurate way of metering, but it does require some experience to do well.

Spot Metering [•] : Spot metering covers only 3.5% of the image in the viewfinder. (The circle etched in the viewfinder indicates the Spot metering area.) It allows you to pinpoint exposure for a small area of the photo. This setting can be used for backlit subjects or a subject in front of a dark background. Experienced photographers are most likely to use this setting. Spot metering is most effective when setting exposure manually. However, it can be used with AE Lock.

Center-Weighted Average Metering [⬚] : This method reads exposure for the entire scene, but in computing the exposure, the camera puts extra emphasis on the reading taken from center of the frame. Since most early traditional SLR cameras used this method exclusively, some photographers have used Center-weighted metering for such a long time that it is second nature and they prefer sticking with it. It can be very useful with scenes that change quickly around the subject.

Judging Exposure
The LCD Monitor gives you an idea of your photo's exposure. The small image displayed there allows you to evaluate the exposure, but realize that it only gives an indication of what you will actually see when the images are downloaded.

The EOS 5D includes two features that are better for interpreting whether or not each exposure is correct. These features, Highlight alert and the Histogram, can be seen on the LCD Monitor once an image is displayed there. Push the Playback button [▶] and use the INFO button to cycle through three levels of image information: the image only; the image with limited information (exposure settings, file name, and frame count); or the image with complete information (highlight alert, histogram, and all the camera settings).

Highlight Alert: The camera's highlight alert is displayed when viewing the image with complete shooting information. Areas of the photo that are overexposed will blink. These areas have so much exposure that only white is recorded, no detail. It is helpful to immediately see what highlights are getting blown out, but some photographers find the blinking is a distraction. Blinking highlights are simply information, and not necessarily bad. Some scenes have less important areas that will get washed out if the most important parts of the scene are exposed correctly. However, if you discover that significant parts of your subject are blinking, the image is likely overexposed. You need to reduce exposure in some way.

The Histogram: The 5D's histogram, though small, is a very important exposure tool for the digital photographer. The histogram is a graphic representation of the brightness range of the image. It covers a range of approximately five stops, shown as solid black lines that divide the graph into five even sections. The tonal range runs from darkest (left) to lightest (right) along the horizontal axis. The vertical axis indicates the pixel quantity existing for each brightness level. Generally, the histogram of a properly exposed image will rise as a slope from the bottom left corner of the histogram, then descend towards the bottom right corner. It may not be an even curve—there may be some spikes or "mountains"—but an average well-exposed image should use the full dynamic range of the camera. Having said this, there are scenes that are naturally dark or light. In these cases, most of the data in the graph will be on the left or right, respectively.

If the graph looks like it is abruptly cut off at either side, then the exposure is also cut off. This indicates that the scene has areas that are darker or brighter than the sensor could capture. The dark sections of your photo may fade to black (with increased noise there), and brighter sections may

The histogram is a graphic representation of all the tones in an image. A well-exposed image that uses the full dynamic range of the sensor has information distributed across the width of the graph. ⇨

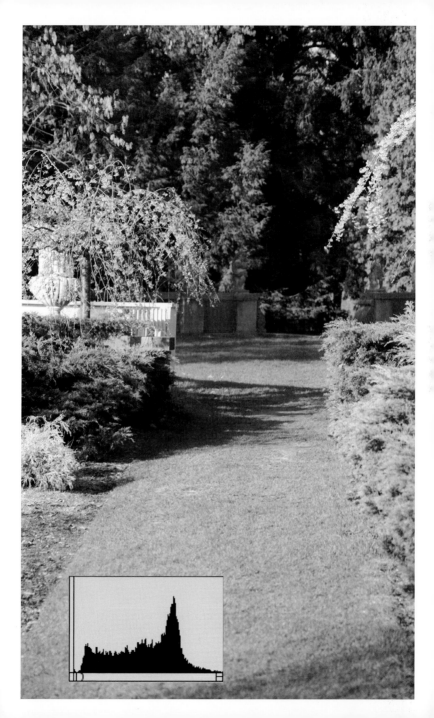

appear completely washed out. If shadow detail is important, be sure the data reaches the bottom of the graph before it hits the left side. If highlights are important, be sure that the data reaches the bottom of the graph before it hits the right side.

Be careful of dark scenes that have too much data in the left half of the histogram. Such underexposure tends to overemphasize any sensor noise that might be present. You are better off increasing the exposure, even if the LCD image looks bright. You can always darken the image in the computer. This has minimal effect on image quality, yet lightening a very dark image usually will have an adverse effect and result in added noise.

If the scene is low in contrast and the histogram is a rather narrow hill in the middle of the graph, check the contrast under the 5D's Picture Style settings. You can create a custom setting with increased contrast that will consistently address such a situation. This can mean better information being captured since it is spread out more evenly across the tones before bringing the image into your computer to use image-editing software. In addition, this type of histogram is better captured using RAW. The full tonal range from black to white can be stretched with better results in RAW.

When an image is displayed with the complete shooting information, the histogram appears on the LCD Monitor to the right of the image. To show the histogram, press the INFO button during image playback until the complete shooting information appears. The 5D actually has two histogram settings: brightness and RGB. The first shows overall image brightness and the other breaks the image tones out into their red, green and blue components showing each in a separate histogram. The RGB histogram can be used to check color saturation, gradation, and balance. To change the histogram setting, press the MENU button and scroll to Histogram in the Playback ▶ menu. Press the Set button (SET) , use the Quick Control Dial ◌ to choose between Bright. and RBG, and press (SET) again to input the selection.

Shutter Speed

The 5D offers a range of shutter speeds from 1/8000 second to 30 seconds in 1/3-or 1/2-stop increments. For flash exposures, the camera will sync at 1/250 second or slower. Slower shutter speeds can be used in combination with flash to record the ambient light in a scene.

Fast shutter speeds can be considered 1/500 second and higher. The obvious reason to choose these speeds is to stop action. The more the action increases in pace, or the closer it crosses directly in front of you, the higher the speed you will need to freeze subject movement. As mentioned previously, the neat thing about a digital camera is that you can check your results immediately on the LCD monitor to see if the shutter speed has in fact frozen the action. Besides stopping action, another important use of the high shutter speeds is to allow you to a large aperture, such as f/2.8 or f/4 for selective focus effects (shallow depth of field). In bright sun with ISO 200, you might have an exposure of 1/200 second at f/16. You can get to f/2.8 by increasing your speed by five whole steps of exposure, to approximately 1/4000 second.

When using fast shutter speeds, camera movement during exposure is rarely significant unless you try to handhold a super telephoto lens of 600mm (not recommended!). This means with proper handholding technique, you can shoot using most normal focal lengths (from wide-angle to telephoto up to about 300mm) with few problems from camera movement.

Moderate shutter speeds (1/500–1/60 second) work for most subjects and allow a reasonable range of f/stops to be used. They are great shutter speeds to use for most subjects, as long as there's no fast action. You do have to be careful when handholding cameras at the lower end of this range, especially with telephoto lenses, or you may notice blur in your pictures due to movement of the camera during the exposure. Many photographers find that they cannot handhold a camera with moderate focal lengths (50-150mm) at shutter speeds less than 1/125 second without some degra-

dation of the image due to camera movement. You can double-check your technique by taking a photograph of a scene while handholding the camera, and then comparing the same scene shot using a tripod.

Slow shutter speeds (1/60–1/8 second) are used mainly for low light conditions, but also may be needed with a very small aperture or a low ISO. At these speeds, even a slight tremor or a breeze can result in an unacceptably unsharp image. The photographer needs to check carefully for subject movement and camera movement, and should magnify the image in the LCD Monitor, if necessary. Usually the camera should be stabilized on a camera support or a firm surface. Some photographers may discover they can handhold a camera and shoot relatively sharp images at the high end of this range, but most cannot get optimal sharpness from their lenses at these speeds without a tripod or other stabilizing mount.

Note: Two general rules for avoiding blur from camera shake: do not handhold the camera at shutter speeds slower than 1/60 second and do not handhold the camera if the reciprocal of the lens focal length is greater than the shutter speed. For example, a 200mm lens should not be handheld at shutter speeds slower than 1/200 second. Super telephotos (400mm and longer) are an exception to this rule. They should always be used on a camera support.

Very slow shutter speeds (1/8–1/2 second) can be used to record a moving subject as an artful blur. Running water looks soft and ethereal and marathon runners look like colorful streaks, but everything stationary in the photo is sharp. These motion effects are quite unpredictable; image review using the LCD Monitor is helpful. You can try different shutter speeds and see the results instantly. This is useful when trying to choose an appropriate slow speed because each speed will blur action differently. The camera must be on a sturdy support and the even pressing the shutter release button too enthusiastically can cause camera movement. Use the self-timer or a cable release, if possible.

You can set really long shutter speeds (up to 30 seconds) for capturing fireworks or the city lights at night. Canon has engineered the sensor and its accompanying circuitry to minimize the noise associated with long exposures and setting Custom Function 2 further reduces this specific type of noise. The 5D offers remarkable results with long exposures.

Aperture

The aperture, sometimes referred to as the f/stop, is the adjustable opening in the lens that controls the quantity of light that hits the camera's sensor. A large aperture lets in more light than a small aperture. Therefore, in the same shooting conditions, a large aperture uses a shorter shutter speed and a small aperture requires a longer shutter speed for proper exposure.

Aperture settings are expressed in f/numbers, e.g. f/2.8 or f/8. A larger number indicates a smaller aperture. The 5D can adjust the aperture in 1/3-stop increments. In Av mode, turning the Main Dial ⌖ changes the aperture, but in Manual mode the Quick Control Dial ◯ is used. Although the camera controls the aperture, it is a component of the lens and the minimum and maximum aperture settings are determined by the lens design.

While the aperture size, affects the amount of light entering the camera, it also has a direct effect on depth of field. (Depth of field is the distance in front of and behind a specific plane of focus that is acceptably sharp.) A small lens opening (higher f/number) such as f/11 or f/16 will increase the depth of field in the photograph, bringing objects in the distance into sharper focus (when the lens is focused appropriately). For architectural or landscape photography, a small aperture is commonly used. The camera will usually be mounted on a tripod, so having a fast shutter speed is not an issue. A large aperture narrows the depth of field, allowing the photographer to selectively focus on the subject. Portrait photographers usually use a large aperture to separate the subject from the background. The person is sharp and the background is reduced to an unobtrusive blur.

Depth-of-Field Preview: You can see the effect of the aperture setting on the image by pushing the Depth-of-Field Preview button on the camera (located on the lower left of the front lens housing, below the Lens Release button). When you look through the viewfinder, you are seeing the image with the lens wide open. Pressing the Depth-of-Field Preview button closes the lens down to the set aperture. This reveals image sharpness, but also darkens viewfinder. Changes in focus can be seen if you look carefully, but using depth-of-field preview takes some practice. You can also check focus in the LCD Monitor after the shot (magnify it as needed), since digital allows you to review your photos as you shoot.

Exposure Modes

The 5D offers six exposure modes. In Full Auto mode, the exposure settings and all the camera controls are set automatically and cannot be adjusted by the photographer. The other five exposure modes offer varying degrees of control to the photographer. All exposure modes are selected by using the Mode Dial on the top left of the camera. Simply rotate the dial to the setting you wish to use.

Full Auto ☐ : For completely automatic shooting, this mode essentially converts the 5D into a point-and-shoot camera (a very sophisticated point-and-shoot!). The camera chooses everything—you have very limited control over the camera settings. This mode is really designed for the beginning photographer who does not trust his or her decisions, or for situations when you hand the camera to someone to take a picture for you.

In Full Auto mode, the focus mode is AI Focus with automatic AF point selection, the metering is Evaluative, drive mode is Single Shooting, and the white balance is Auto. The photographer cannot change these settings or use any functions, such as program shift, exposure compensation, AEB, ISO selection. Also, the file format cannot be set to RAW.

In Program AE mode, the camera sets both the aperture and shutter speed. You can shift the exposure settings by turning the Main Dial or the Quick Control Dial.

Program AE Mode (P): In Program AE (autoexposure) mode, the camera chooses the shutter speed and aperture combination. Exposure is set based on the meter reading, information, such as the lens focal length, and a set of preprogrammed values used to evaluate the input. This mode gives the photographer less direct control over the exposure settings. However, you can shift the program to change either the aperture or shutter speed selected by the camera, and the system will compensate to maintain the same exposure value. To shift the program, simply press the shutter release button halfway so that the shutter speed and aperture appear on the LCD panel. Then, turn the Main Dial or Quick Control Dial until the desired shutter speed or aperture setting respectively is displayed. This only works for one exposure at a time, making it useful for quick-and-easy shooting while retaining some control over camera settings.

If the system determines there is risk of a bad exposure, the shutter speed and aperture values will blink in the viewfinder. When this occurs because there is too much light, you can decrease the ISO setting. Also, a neutral-density (ND) or polarizing filter can be used to reduce the light coming into the lens. If there is insufficient light, either increase the ISO speed or use flash.

Shutter-Priority AE Mode (Tv): Tv (time value) is the setting for Shutter-Priority AE mode. Shutter-Priority means that you select a shutter speed by turning the Main Dial 🔄 and the camera sets the corresponding aperture for proper exposure. If you want a particular shutter speed for artistic reasons, for example to stop action or produce motion blur, this is the setting to use. In this mode, even if the light varies, the shutter speed will not. The camera will compensate for changing light by adjusting the aperture automatically. The set aperture will appear in the viewfinder and on the LCD Panel. If the maximum aperture (lowest number) blinks, it means the photo will be underexposed and you need to select a slower shutter speed by turning the 🔄 until the aperture indicator stops blinking. You can also remedy this by increasing the ISO. If the minimum aperture (highest number) is blinking, this indicates overexposure. In this case, you should set a faster shutter speed until the blinking stops, or set a lower ISO.

Aperture-Priority AE Mode (Av): When you select Av (aperture value), you are in Aperture-Priority AE mode. In this autoexposure mode, you set the aperture using the Main Dial 🔄 and the camera selects the proper shutter speed for exposure. If the shutter speed is blinking in the LCD Panel, it means good exposure is not possible at that aperture, so you either need to change the aperture or ISO setting. This is probably the most popular autoexposure setting among professional photographers.

Controlling depth of field is one of the most common reasons for using Aperture-Priority mode. Higher f/numbers have greater depth of field—great for landscape photography. A

wide lens opening with a low f/number, such as f/2.8 or f/4, will decrease the depth of field. These lower f/numbers work well for when you want your subject to be sharp against a soft, out-of-focus background, for example in a portrait.

A sports or wildlife photographer might choose Av mode in order to stop action rather than to capture depth of field. By selecting a large aperture, f/2.8 or f/4, the camera will then automatically select the fastest shutter speed possible for the conditions. With Shutter-Priority mode you can set a fast shutter speed, but if the lens is at the largest aperture setting and the light drops, you'll get an underexposure warning. This may cause you to miss a shot. So typically photographers will select Tv only when they have to have a specific shutter speed. Otherwise they use Av for both depth of field control and to gain the highest possible shutter speed for the circumstances.

Manual Exposure Mode (M): In Manual Exposure mode, the photographer has complete control over exposure. You set both the shutter speed using the Main Dial ⚙ and aperture using the Quick Control Dial ◯ (the power switch ◈ must be set to the angled line ⌒). To set exposure, use the exposure scale at the bottom of the viewfinder and on the LCD Panel. The meter's recommendation for correct exposure is at the mid-point. Adjust the shutter speed and/or aperture until the indicator on the scale is at the mid-point. You can then vary the exposure settings from the meter's recommendation, if desired, by observing the scale. It shows up to two stops over- or underexposure, which can allow you to quickly compensate for bright or dark subjects. If the exposure indicator blinks, the exposure is beyond the range of the scale.

The Manual Exposure option is important for photographers who need to control exposure. Manual mode is essential for photographers shooting in a studio with professional strobe lighting. It is also the mode to use in certain tricky situations. The following examples of complex metering conditions might require you to use M mode: panoramic shooting (you need a consistent exposure across the multiple shots

taken, and the only way to ensure that is with Manual); lighting conditions that change rapidly around a subject with consistent light (a theatrical stage, for example); close-up photography where the subject is in one light but slight movement of the camera dramatically changes the light behind it; and any conditions where you need a consistent exposure through varied lighting conditions.

Bulb Exposure Mode (B): The Bulb Exposure mode allows you to control long exposures. With this option, the shutter stays open as long as you keep the shutter release button depressed. When you release the shutter release button, the shutter closes. The upper right corner of the LCD Panel displays the elapsed exposure time in seconds (up to 999.) The camera must be on a tripod or some firm support when this setting is used. This is the exposure to use for photographing fireworks, the night sky, and other low-light situations.

Long exposures can create image noise. The EOS 5D has a Custom Function that deals specifically with this type of noise. Set C.Fn-02 to either 1 for Auto noise reduction or 2 for ON. This will process the images in-camera to reduce the appearance of noise.

In contrast to long film exposures, long digital exposures are not subject to reciprocity failure. As exposure time increases beyond about 1 second, the sensitivity of the film declines resulting in the need to increase exposure to compensate. If an exposure time of 30 seconds produces an accurate exposure with a digital camera, a 60- or 90-second exposure would be required to properly expose film. Just another benefit that digital offers.

Two accessories from Canon, the Remote Switch (RS-80N3) and the Timer Remote Controller (TC-80N3), are very helpful for these long exposures. They allow you to hold the shutter open for long exposures without touching the camera, which can cause image blur due to camera movement. They attach to the remote terminal on the camera's left side.

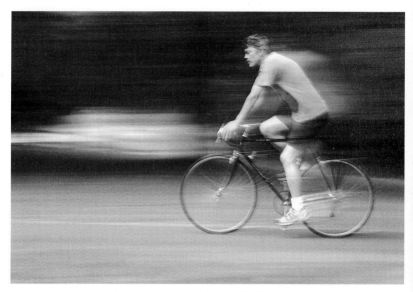

Panning—tracking a moving subject with the camera—requires a slow shutter speed to achieve the effect of movement. Use Shutter-Priority AE mode to control the shutter-speed setting and let the camera set the corresponding aperture.

Camera User Setting C : The final setting on the Mode Dial allows you to recall a specific combination of camera controls that you have input. Consider that the EOS 5D has over 25 separate controls, plus the Custom Functions and you'll appreciate how useful this feature can be. Menu settings, exposure compensation, custom white balance, AEB, and numerous other functions can all be preset and then accessed with a turn of the Mode Dial. You have complete freedom to adjust most settings as you shoot without altering the registered program. Just turn the camera off or turn the Mode Dial to clear any changes. When you turn the camera on or turn the Mode Dial back to C, it will restore the settings that you registered. To customize the Camera User Setting, set all the various camera controls and register the settings you have selected using the Set-up menu. To use the registered settings, turn the Mode Dial to C. Pressing the

INFO button will display the registered settings on the LCD Monitor. (For more complete information, see "Customizing Your Camera" on page 81.)

AE Lock
Normally, the EOS 5D continually updates exposure either as you move the camera across the scene or as the subject moves. This can be a problem if a subject is backlit or the background light is changing. AE Lock ✳ allows you to set exposure for the subject and hold the shutter speed and aperture settings. The meter is "disengaged" so that changes in the lighting will not affect the exposure settings.

AE Lock ✳ on the 5D is similar to most EOS cameras. Its button is signified by an asterisk and is located on the back of the camera to the upper right. Aim the camera to set the proper exposure, and then push the AE Lock button ✳ to hold the exposure settings. An asterisk will appear in the Viewfinder information display. The exposure settings will not change as long as the camera is active. AE Lock ✳ is cancelled when the camera is inactive (the viewfinder display goes dark and the shutter speed and aperture disappear from the LCD Panel).

With the camera set to One-Shot AF, holding the shutter release button will lock focus and also the exposure settings. Using AE Lock ✳ is preferable when you want to control focus and exposure separately.

Exposure Compensation
The 5D has an excellent metering system, but it is not perfect. Excessively dark or light subjects or scenes may not be properly exposed. The meter wants to increase exposure on dark subjects and decrease exposure on light subjects to make them closer to middle gray. For this reason exposure compensation may be necessary. Exposure compensation cannot be used in Full Auto or Manual mode. However, it makes the P, Tv, and Av modes much more versatile. Compensation is added (for brighter exposure) or subtracted (for darker exposure) in 1/3-increments of up to +/- 2 stops.

Let's say you are photographing skiers coming down a mountain. The camera takes a meter reading of the bright white snow and wants to underexpose the images. The resulting photos have gray snow and the skiers are dark and featureless. You will want to override the meter and increase exposure with the 5D's Exposure Compensation feature.

The LCD Monitor can come in handy when experimenting with exposure compensation. Take a test shot, and then check the photo and its histogram. If it looks good, go with it. If the scene is too bright, subtract exposure; if it's too dark, add it. With experience, you will find that you use exposure compensation routinely with certain subjects.

Exposure compensation is set with the Quick Control Dial ⊙ . Set the Power switch ⊚ to the angled line ⟋ so that the Quick Control Dial ⊙ is on. The camera must be active. Press the shutter release button so the shutter speed and aperture appear in the Viewfinder and on the LCD Panel. Rotate the ⊙ to change the compensation amount. You will see the exact exposure compensation on the scale at the bottom of the Viewfinder information display, as well as on the LCD Panel. Just remember that once you set Exposure Compensation, it stays set even if you shut off the camera. Check your exposure setting as a regular habit when you turn on your camera to be sure the compensation is not inadvertently set for a scene that doesn't need it.

Autoexposure Bracketing (AEB)

The autoexposure bracketing control (AEB) is an exposure safeguard for unusual lighting situations. AEB sets the camera to make three varying exposures: a standard exposure, an image with less exposure, and an image with more exposure. (The sequence of these shots can be changed with Custom Function 09.) The difference between exposures can be up to +/- 2 stops in 1/3-stop increments. (Custom Function 6 changes this to 1/2-stop increments.) The Exposure mode you use will affect how the AEB adjusts exposure. In P, Av, and M mode, the 5D will change the shutter speed and in Tv mode, the aperture setting will change. When in Single

shooting mode, you have to press the shutter release button for each of the three shots. In Continuous shooting modes, the camera will take the three shots and then stop. With the self-timer, all three shots will be taken.

AEB is set through the Shooting menu ◘ . Scroll to AEB with the Quick Control Dial ◎ , press the Set button ⒮ , and use the ◎ again to set the amount. Three markers will appear on a small exposure scale on this menu. These indicate the range of the exposures. Press the ⒮ to input the setting. When AEB is set, you will see the AEB symbol on the LCD panel and the exposure scale on the LCD panel and in the viewfinder will show three exposure markers. Press the shutter release halfway and the only marker shown is for the exposure that will be made. If you use AEB, remember that the camera will continue to take three different exposures until you reset the control to zero, turn the camera off, change lenses, change the battery, or replace the CF card.

Autoexposure bracketing can help ensure that you get the best possible image files for later adjustment using image-editing software. A dark original file always has the potential for increased noise as it is adjusted, and a light image may lose important detail in the highlights. AEB can help you to determine the best exposure for the situation. You won't need it all the time, but it can be useful when the light in the scene varies in contrast or is complex in its dark and light values. AEB is also important for a special digital editing technique that allows you to combine multiple exposures into one master image. You can take the well-exposed highlights of one exposure and combine them with the better-detailed shadows of another. You must put your camera on a tripod, so that the exposures will line up exactly, making the different exposures easier to combine.

Drive Modes and the Self-Timer

The 5D offers two shooting speeds. Single shooting mode takes one exposure each time you press the shutter release and Continuous shooting mode captures up to three frames per second while the shutter release button is held down. There is also an option for a self-timer ⟳ .

 Single shooting mode ☐ is the commonly used drive setting. It is your only option when using Full Auto mode. Continuous shooting mode ⊒ is typically used for active or moving subjects, such as sports or wildlife. It can be difficult to time your shots just right when your subject is in motion. You have a better chance of getting that "one perfect moment" if you have a series of sequential photos to choose from. Although the 5D can shoot at three frames per second, there are limitations to the number of exposures (or maximum burst) you can capture with the Continuous shooting mode ⊒ . The image-recording quality has the greatest effect on this number. During Continuous shooting, images are first stored in the camera's buffer and then written to the CF card. When the buffer is full, the 5D will display "buSY" on the LCD panel and in the viewfinder. You must wait for the buffer to be cleared to resume shooting. Obviously, if you are capturing large files, the buffer will fill up more quickly. Canon estimates a maximum burst of 17 RAW files or 60 large, fine-quality JPEGS. Your CF card's write speed can also affect the maximum burst. In the viewfinder next to the focus confirmation, there is a counter for the number of exposures you can take with Continuous shooting mode ⊒ . The counter starts at 9, indicating you have a maximum burst of nine or more shots. When there are less than nine shots remaining, the indicator will count down. This drive mode can drain battery power and quickly fill up a CF card. Keep a close watch on both while shooting.

 The self-timer allows for a ten-second delay between the time you press the shutter release button and when the camera takes the exposure. An audible tone will sound and the self-timer light on the front of the camera will blink as the

timer counts down. (When using the self-timer with mirror lock-up, there is only a two-second delay.) Most people associate the self-timer with group photos and running to get into position after pressing the shutter release. It is also useful for shooting at slow shutter speeds with the camera on a tripod, especially if you don't use a cable release to trip the shutter. The ten-second delay provides time for camera vibrations to settle down before the shutter goes off.

The Drive mode is selected by pressing the DRIVE•ISO button then rotating the Main Dial ⚙ . The chosen drive mode will appear in the LCD Panel as ☐ for Single shooting mode, as ᏪᏆ for Continuous shooting mode, or as ঔ for self-timer operation.

Focus

Canon has updated the 5D's autofocus system with new algorithms and newly designed circuitry for improved subject detection and precision focusing with significantly enhanced subject tracking. The all-new, AF system uses nine selectable AF sensors with six supplemental AF sensors. Of these 15 points, all are f/5.6 sensitive meaning that autofocus is possible with lenses as slow as f/5.6. The three center sensors (one selectable and two supplemental) are also f/2.8 sensitive when a lens of f/2.8 or faster is used allowing for precision focus detection. In addition, the three center AF sensors are cross sensors meaning they are sensitive to both horizontal and vertical lines. The AF system works with an EV (exposure value) range of -0.5 to 18 (at ISO 100). When light levels are low, an EOS-dedicated Speedlite equipped with a near-infrared autofocus-assist beam will produce a series of quick flashes to aid the camera's AF system. With these improvements, the 5D's AF system does a better job of detecting difficult-to-read or low-contrast subjects, thus improving the camera's overall performance.

Focus Modes

The camera has four focus modes: One-Shot AF, AI Focus AF, AI Servo AF, and Manual Focus. Manual focus is not actually a camera setting; there is an AF/MF switch on the lens. With this switch set to MF, the photographer turns the lens' focus ring to achieve focus. To use autofocus, this switch must be set to AF. Then, press the AF•WB button located on top of the camera in front of the LCD Panel. Use the Main Dial to scroll to the mode you want to use. The AF setting appears in the box in the lower right corner.

One-Shot AF: This AF mode finds and locks focus when you press the shutter button halfway. (The exposure settings will be locked as well.) To indicate the area of the photo that is in focus, the active AF sensor will blink red. The camera will give an audible tone (two quick beeps) and the focus confirmation light will glow steadily in the viewfinder when you have locked focus. It will blink when the camera can't achieve focus.

This mode is perfect for stationary subjects. It allows you to find focus and hold it on the area of the photo that you want to be sharp. If the camera doesn't hit the right spot, it is a simple and quick matter to slightly change the framing and repress the shutter button halfway to lock focus. Once you have locked focus, you can then move the camera to set the proper composition.

AI Focus AF: In this mode, the camera switches between One-Shot and AI Servo AF as needed. Initially, this setting acts like One-Shot AF, you focus on a subject, the focus confirmation light glows and the AF point(s) illuminate in the viewfinder. If that subject should start to move, the 5D will automatically use AI Servo AF to maintain focus. Note, however, that if you are photographing a stationary subject, like a monument, the AF system may detect movement in the scene, such as people walking around the monument, and may not lock onto the non-moving subject.

AI Servo AF: Great for action photography, AI Servo becomes active when you press the shutter button down halfway, but it does not lock focus. It continually looks for the best focus as you move the camera or as the subject travels through the frame. It is really designed for moving subjects, so both the focus and exposure are set only at the moment of exposure. However, if the subject is not moving, the AI Servo AF focus control is exceptionally stable. The 5D will hold focus on a stationary subject, unless you are hand-holding the camera and there is camera movement.

If you are using AI Servo AF on a moving subject, it is a good idea to activate focus by depressing the shutter halfway before you actually need to take the shot so that the system can locate the subject. The camera's ability to autofocus while tracking a moving subject is quite good. According to Canon in AI Servo AF with an EF 300mm f/2.8 USM lens, the 5D can maintain focus on a subject that is up to 66 feet (20 meters) away and moving toward the camera at a speed of 186 mph. It has the ability to very quickly employ statistical prediction while using multiple focusing operations to follow even an erratically moving subject.

Manual Focus: Manual focus is not a camera setting. To use manual focus, set the switch on the lens to MF and turn the focus ring until the scene appears sharp in the viewfinder. If you press the shutter button halfway during manual focus, the focus confirmation light and the active AF point will illuminate when focus is achieved. You'll also hear the audible tone.

Selecting an AF Point: You can have the camera select the AF point automatically, or you can select a desired point. Manual AF point selection is useful when you have a specific composition in mind and the camera won't focus on the portion of the subject that you want sharp. When the camera achieves focus, the AF point or points used will glow red momentarily.

To manually select an AF point, simply push the AF point selection button ⊞ and turn the Main dial 🗘 or Quick Control dial ◯ or move the Multi-controller ✳ in any direction to select a focus point. Points light up as they are selected. Using one of the dials to set an AF points is slower because you have to circulate through each point sequential. Using the ✳ allows you to jump to any point by pushing the controller in that direction. If you use the ✳ to select an already lit point, the camera defaults to auto AF point selection. Pressing in the center of the ✳ will automatically select the center point. It is an intuitive control that is simple to use.

AF Limitations: AF sensitivity is high with this camera. You will discover that the 5D can autofocus in conditions that are quite challenging for other cameras. Still, as the maximum aperture of lenses decreases, or tele-extenders are used, the camera's AF capabilities will change.

One common reason the camera can't focus, is that your subject may be closer than the minimum focus distance for the lens. Try moving back from the subject a little to see if that helps. It is also possible that the camera will not be able achieve focus in certain situations, requiring you to focus manually. This would be most common where the scene is low-contrast or has a continuous tone (such as sky), in conditions of extremely low light, with subjects that are strongly backlit or have glare behind them, and with compositions that contain repetitive patterns. In these situations, manual focus is recommended. As an alternative, you can focus on something at the same distance as the subject, lock focus on it, then move the framing back to the original composition.

Flash

With the EOS 5D, you are getting more than just a superior D-SLR. The Canon system of flash, called Speedlites, include a series of EX models up to the compact, and extremely sophisticated 580EX.

Many photographers seem intimidated by flash, and for good reason. It used to be you could not see its effects or how good your exposure was until you got the film processed. Even highly sophisticated pros used Polaroid film tests because they could not totally predict what the flash would look like in the photo.

Digital photography has changed all that. With the LCD review on the back of your 5D, you can instantly see the effects of any use of flash and instantly adjust the light level higher or lower, change the angle, soften the light, color it, and more. You can experiment with the built-in flash or you may even find that an accessory flash unit can help with your photography.

You may know all about the use of electronic flash, but I know a lot of very good photographers new to the EOS D-SLR line don't know all that a flash can do for them. Electronic flash is not just a supplement for low light; it can also be a wonderful tool for creative photography. Flash is highly controllable, its color is precise, and the results are repeatable.

However, the challenge is getting the right look, and many photographers shy away from using flash because they aren't happy with the results. This is because on-camera flash can be harsh and unflattering, and taking the flash off

◁ **To use the 5D with studio strobe lighting, connect a sync cord to the camera's PC terminal or use a wireless remote trigger. ©Joe Farace.**

the camera used to be a complicated procedure with less than sure results. The EOS 5D's sophisticated flash system eliminates many of these concerns and, of course, the LCD Monitor gives instantaneous feedback. This alleviates the guesswork.

Here are some possibilities for using flash with your EOS 5D:

Fill Flash—Fill in harsh shadows in all sorts of conditions and use the LCD Monitor to see exactly how well the fill flash is working. You can even dial down the built-in or accessory flash to make its output more natural looking.

Off-Camera Flash—Putting a flash on a dedicated flash cord will allow you to move the flash to positions away from the camera and still have it work automatically. Using the LCD Monitor, you can see exactly what the effects are so you can move the flash up or down, left or right, for the best light and shadows on your subject. With Canon's EX Speedlites, you can also trigger certain units wirelessly, so you can have a flash off the camera and no cords attached.

Close-Up Flash—This used to be a real problem, except for those willing to spend some time experimenting. Now you can see exactly what the flash is doing to the subject. This works fantastically well with off-camera flash, as you can "feather" the light (aim it so it doesn't hit the subject directly) to gain control over its strength and how it lights the area around the subject. Canon's EX Speedlites include a special twin flash macro unit, though you can use most units for close-up work.

Multiple Flash—Modern flash systems have made exposure with multiple flash easier and more accurate. Plus, many manufacturers have created cordless systems. However, since the flash units are not on continuously, they can be hard to place so that they light the subject properly. Not anymore. With the 5D, it is easy to set up the flash, and then take a test shot. Does it look good or not? Make changes if you need to. In addition, this camera lets you use certain

Compare the flash photo (top) to the photo taken with available light (bottom). To separate the subject from the background, flash was used to illuminate the monument and the aperture was stopped down to darken the background.

EX-series flash units (and independent brands with the same capabilities) that offer wireless exposure control. Digital photography is a great way to learn how to master multiple flash set ups because of the instant feedback.

Wireless Flash—Canon has an excellent system that offers complete wireless control of multiple flash units that can be triggered and controlled automatically.

Adding Colored Light—Many flashes look better with a slight warming filter on them, but that is not what this tip is about. With multiple light sources, you can attach colored filters (also called gels) to the various flashes so that different colors light different parts of the photo (this can be a very trendy look).

Balancing Mixed Lighting—Architectural and corporate photographers have long used added light to fill in dark areas of a scene so the scene looks less harsh. Now you can double-check the light balance on your subject using the LCD Monitor. You can even be sure the added light is the right color by attaching filters to the flash to mimic or match lights (such as a green filter to match fluorescents or an amber filter to blend with incandescent lights).

Flash Synchronization

Understanding how the camera syncs the burst of flash light to the opening of the shutter is key to getting the most from flash with your 5D. The camera is equipped with an electro-magnetically timed, vertically traveling focal-plane shutter. This shutter uses two curtains, one opens to expose the sensor to light, the second closes to shut off that light. For normal flash operation, the flash must go off when the sensor is fully exposed to light from the lens.

One characteristic of focal-plane shutters, however, is that the entire surface of the sensor will not be exposed at the same time at shutter speeds faster than the flash sync speed. What happens is that the second curtain starts closing off the sensor before the first one has finished going across it. The shutter then forms a slit, which exposes the sensor as it moves across it. If you use flash with a shutter speed that is higher than the maximum flash sync speed, you get only a

partially exposed picture. However, at shutter speeds below the maximum, the whole sensor surface will be exposed at some point to accept the flash; you can use any shutter speed you want that is 1/250 second or slower.

With the 5D, the maximum flash sync speed ranges from 1/30 second to 1/250 second. There is a qualification to that: the camera does offer high-speed sync with certain EX-series flash units that allow flash at all shutter speeds (even 1/8000 second where, basically, the flash fires continuously as the slit goes down the sensor). High-speed synchronization must be activated on the flash unit itself and is indicated by an "H" symbol on the flash unit's LCD display; see the flash manual for specific information on using high-speed flash sync. It does have some limitations, including how much power you get.

Guide Numbers

When shopping for a flash unit, compare guide numbers. A guide number (GN) is a simple way to state the power of the flash unit (it's computed as the product of aperture value and subject distance) and is usually included in the manufacturer's specifications for the unit. High numbers indicate more power, however, it is important to understand that these numbers do not represent a linear relationship. Guide numbers act a little like f/stops (because they are directly related to f/stops!)—e.g., 56 is half the power of 80, or 110 is twice the power of 80. Since guide numbers are expressed in feet and/or meters, distance is part of the guide number formula. Guide numbers are usually based on an ISO 100 setting, but this can vary, so check the film speed reference (and determine whether the GN was calculated using feet or meters) when comparing guide numbers for different units. If the flash units you are comparing have zoom-head controls, make sure you compare the guide numbers for similar zoom-head settings.

Flash Metering

To understand the 5D's flash metering, you need to understand how a flash works with a digital camera on automatic. The 5D uses an evaluative auto exposure system, called E-TTL II, with improved flash control over earlier models (it is based on the E-TTL II system introduced in the pro-level EOS-1D Mark II and also used in the EOS-1D Mark IIN). The camera will cause the flash to fire twice for the exposure. First, a preflash is fired to allow the camera to analyze exposure, and then the flash fires during the actual exposure, creating the image. During the preflash, the camera's evaluative metering system measures the light reflected back from the subject. Once it senses that the light is sufficient, it cuts off the flash and takes the actual exposure with the same flash duration. The amount of flash hitting the subject is based on how long the flash is "on," so close subjects will receive shorter flash bursts than more distant subjects. This double flash system works quite well, but you may also find that it causes some subjects to react by closing their eyes during the real exposure. However, they will be well exposed!

You can lock the flash exposure by pressing the FE (Flash Exposure) Lock button ✳ (this is the same as the Exposure Lock button located on the upper right back of the camera). This causes the camera to emit a pre-flash so that it calculates the exposure before the shot. This also cancels the preflash that occurs immediately before the actual photograph (reducing the problem with people reacting to a preflash that occurs a split-second before the actual exposure).

To use this feature, turn the flash on, then lock focus on your subject by pressing the shutter release button halfway down. Next, aim the center of the viewfinder at the important part of the subject and press the FE Lock button (this icon ⚡* will appear in the viewfinder). Now, reframe your composition and take the picture. FE Lock produces quite accurate flash exposures.

Using the same principle, you can make the flash weaker or stronger. Instead of pointing the viewfinder at the subject to set flash exposure, point it at something light in tone or a subject closer to the camera. That will cause the flash to give less exposure. For more light, aim the camera at something black or far away. With a little experimenting, and by reviewing the LCD Monitor, you can very quickly establish appropriate flash control for particular situations.

For the most control over flash, use the 5D's Manual exposure (M) setting. Set an exposure that is correct overall for the scene then turn on the flash (flash exposure will still be E-TTL automatic.) The shutter speed (as long as it is the flash sync speed or slower) controls the overall light from the scene (and the total exposure). The f/stop controls the exposure of the flash. So to a degree, you can make the overall scene lighter or darker by changing shutter speed, with no direct effect on the flash exposure (this does not work with high-speed flash).

Flash with Camera Exposure Modes

In the Creative Zones, the flash will operate in the various modes as detailed below:

Program AE (P)

Flash photography can be used for any photo where supplementary light is needed. All you have to do is turn on the flash unit—the camera does the rest automatically. Speedlite EX flash units should be switched to E-TTL and the ready light should be on, indicating that the flash is ready to fire. While shooting, you must pay attention to the flash symbol in the viewfinder to be sure that the flash is charged when you are ready to take your picture. The 5D sets flash synchronization shutter speeds automatically in P mode and also selects the correct aperture. When the flash is turned on, any Program shift that has been set will be canceled.

Shutter-Priority AE (Tv)

This mode is a good choice in situations where you want to control the shutter speed when you are also using flash. In Tv mode, you set the shutter speed before or after a dedicated accessory flash is turned on. All shutter speeds between 1/250 second and 30 seconds will synchronize with the flash. With E-TTL Flash in Tv mode, synchronization with longer shutter speeds is a creative choice that allows you to control the ambient-light background exposure. A portrait of a person at dusk in front of a building with its lights on shot with conventional TTL flash would illuminate the person correctly but would cause the background to go dark. However, using Tv mode, you can control the exposure of the background by changing the shutter speed. (A tripod is recommended to keep the camera stable during long exposures).

Aperture-Priority AE (Av)

Using this mode lets you balance the flash with existing light, and it allows you to control depth of field in the composition. By selecting the aperture, you are also able to influence the range of the flash. The aperture is selected by turning the Main Dial 🗲 and watching the flash's LCD display until the desired range appears. Then the camera calculates the lighting conditions and automatically sets the correct flash shutter speed for the ambient light.

Manual Exposure (M)

Going Manual gives you the most choices in modifying exposure. The photographer who prefers to adjust everything manually can determine the relationship of ambient light and electronic flash by setting both the aperture and shutter speed. Any aperture on the lens and all shutter speeds between 1/250 second and 30 seconds can be used. If a shutter speed above the normal flash sync speed is set, the 5D switches automatically to 1/250 second to prevent partial exposure of the sensor.

M mode also offers a number of creative possibilities for using flash in connection with long shutter speeds. You have no need to calculate exposure manually because the flash

sets exposure based on the f/stop you choose, plus you can check exposure in the LCD. You could use zooming effects with smeared background and a sharply rendered main subject, or take photographs of objects in motion with a sharp "flash core" and indistinct outlines.

Red-Eye Reduction

The 5D does offer a red-eye reduction feature for flash exposures. In low-light conditions when the flash is close to the axis of the lens, the flash will reflect back from the retina of peoples' eyes (because their pupils are wide). This appears as "red eyes" in the photo. You can reduce the chances of red-eye appearing by using an off-camera flash or by having the person look at a bright light before shooting.

The red-eye reduction feature of a camera is designed to cause the pupils of your subject to contract. On many cameras this is of questionable value because the flash fires a burst of light before the actual exposure. This often causes less than flattering expressions from your subject. The 5D, on the other hand, uses a continuous light from a bulb next to the handgrip, just below the shutter release button (you do have to be careful not to block it with your fingers), which helps the subject pose with better expressions. Red-eye reduction is set in the Shooting menu 📷 under Red-eye On/Off.

Canon Speedlite EX Flash Units

Canon offers a range of accessory flash units, called Speedlites, in the EOS system. While Canon Speedlites don't replace studio strobes, they are remarkably versatile. These highly portable flash units can be mounted in the camera's hot shoe or used off camera with a dedicated cord. The 5D is compatible with the EX-series of Speedlites. The EX-series flash units range in power from the Speedlite 580EX, which has a maximum GN of 190 (ISO 100, in feet), to the small

and compact Speedlite 220EX, which has a GN of 72 (ISO 100, in feet). Speedlite EX-series flash units offer a wide range of features to expand your creativity. These are designed to work with the camera's microprocessor to take advantage of E-TTL exposure control, which extends the abilities of the 5D considerably.

I also strongly recommend Canon's Off-Camera Shoe Cord 2, an extension cord for your flash. With this cord, the flash can be moved away from the camera for more interesting light and shadow. You can aim light from the side or top of a close-up subject for variations in contrast and color. If you find that you get an overexposed subject, rather than dialing down the flash (which can be done on certain flash units), just aim the flash a little away from the subject so it doesn't get hit so directly by the light. That is often a quick fix for overexposure of close-ups.

Canon Speedlite 580EX
This top-of-the-line flash unit offers outstanding range and features adapted to digital cameras. It has many features in common with the 550EX but is slightly more powerful, has a faster recycling time, and is a more compact. The tilt/swivel zoom head on the 580EX covers focal lengths from 14mm to 105mm, and it swivels a full 180° in either direction. The zoom positions (which correspond to the focal lengths 24, 28, 35, 50, 70, 80, and 105mm) can be set manually or automatically (the flash reflector zooms with the lens). In addition, this flash "knows" what size sensor is used with a D-SLR and will vary its zoom accordingly. With the built-in retractable diffuser in place, the flash coverage is wide enough for a 14mm lens. It provides a high flash output with a GN of 190 (ISO 100, in feet) when the zoom head is positioned at 105mm. The guide number decreases as the angular coverage increases for shorter focal lengths, but is still quite high with a GN of 145 at 50mm, or GN 103 at 28mm.

The large, illuminated LCD Panel on the 580EX provides clear information on all settings: flash function, reflector position, working aperture, and flash range in feet or meters.

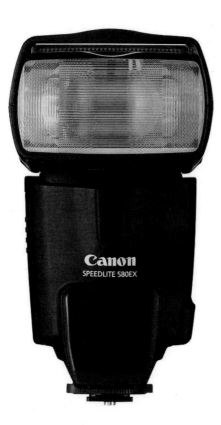

Canon Speedlite 580EX

The flash also includes a new Select Dial for easier selection of these settings. When you press the 5D's Depth-of-field Preview button (on lower left of the lens mount housing), a one-second burst of light is emitted. This modeling flash allows you to judge the effect of the flash. The 580EX also has 13 user-defined custom settings that are totally independent of the camera's custom functions; for more information, see the flash manual. When using multiple flashes, the 580EX can be used wirelessly either as a master flash or a slave unit.

Canon Speedlite 550EX

This model provides a GN of 182 (ISO 100, in feet) when the zoom head is positioned at 105mm. The guide number decreases as the angular coverage increases for wider angle lenses, but is still quite high with a GN of 139 at 50mm or GN 99 at 28mm. The tilt/swivel zoom head on the 550EX covers focal lengths from 24mm to 105mm. The zoom positions (which correspond to the focal lengths 24, 28, 35, 50, 70, 80, and 105mm) can be set manually or automatically (the flash reflector zooms with the lens). With the built-in retractable diffuser in place, the flash coverage is wide enough for a 17mm lens.

Just like the 580EX, the 550EX features a large, illuminated LCD Panel that provides clear information on all settings. It also works like the 580EX when you press the Depth-of-field Preview button to judge the effect of your flash. This unit also has six custom settings that can be defined by the user. When using multiple flash units, the 550EX can be used wirelessly either as a master flash or a slave unit.

Canon Speedlite 420EX

The 420EX is less complicated, more compact, and less expensive than the top models. It offers E-TTL flash control, wireless E-TTL operation, and high-speed synchronization. The 420EX flash unit provides high performance with a GN of 138 (ISO 100, in feet) with the zoom reflector set for 105mm (somewhat weaker than the 550EX, but still quite powerful). The tilt/swivel zoom reflector covers focal lengths from 24 to 105mm. The zoom head operates automatically for focal lengths of 24, 28, 35, 50, 70 and 105mm. The setting for wireless E-TTL is made on the flash foot. When using multiple flashes, the 420EX can be used as a slave unit, but not as a master flash.

Other Speedlites

The Canon system also includes two specialized flash units for close-up photography that work well with the EOS 5D: the Macro Twin Lite MT-24EX and the Macro Ring Lite MR-14EX. They provide direct light on the subject.

Macro Twin Lite MT-24EX

The MT-24EX uses two small flashes affixed to a ring that attaches to the lens. These can be adjusted to different positions to alter the light and can be used at different strengths so one can be used as a main light and the other as a fill light. If both flash tubes are switched on, they produce a GN of 72 (ISO 100, in feet), and when used individually the guide number is 36. It does an exceptional job with directional lighting in macro shooting.

Macro Ring Lite MR-14EX

The MR-14EX has a GN of 46 (ISO 100, in feet) and both flash tubes can be independently adjusted in 13 steps from 1:8 to 8:1. It is a flash that encircles the lens and provides illumination on axis with it. This results in nearly shadowless photos (the shadow falls behind the subject compared to the lens position, though there will be shadow effects along curved edges). This flash is often used by photographers who want to show all the fine detail and color in a subject. It cannot be used for varied light and shadow effects. This flash is commonly used in medical and dental photography so that important details are not obscured by shadows.

Note: The power pack of both of these specialized flash units fits into the flash shoe of the camera. In addition, both macro flash units offer the same technical features as the 550EX, including E-TTL operation, wireless E-TTL flash, and high-speed synchronization among others. The MT-24EX models can also be used for wireless E-TTL flash.

Note: When the 5D is used with older system flash units (such as the EZ series) set in the TTL or A-TTL autoflash mode, the flash will fire at full output only.

Bounce Flash

Direct flash can often be harsh and unflattering, causing heavy shadows behind the subject or underneath features such as eyebrows and bangs. Bouncing the flash softens the light and creates a more natural-looking light effect. The Canon Speedlite 580EX, 550EX, and 420EX accessory flash units feature heads that are designed to tilt so that a shoe-mounted flash can be aimed at the ceiling to produce soft, even lighting. The 580EX and 550EX also swivel (the 580EX 180° in both directions) so the light can be bounced off something to the side of the camera (a wall or reflector). However, the ceiling or wall must be white or neutral gray, or it may cause an undesirable color cast in the finished photo.

Wireless E-TTL Flash

With the wireless E-TTL feature, you can use up to three groups of Speedlite 580EXs, 550Exs, or 420EXs for more natural lighting or emphasis (the number of flash groups is limited to three, but the number of actual flash units is unlimited). The master unit and the camera control the exposure. A switch on the back of the foot of the 580EX and 550EX allows you to select whether the flash will be used as a master or a slave flash in the set up. The 420EX can only be used as a slave unit. Other wireless flash options include the Speedlite infrared transmitter (ST-E2), or the Macro Twin Lite MT-24EX.

To operate wireless TTL, a Speedlite 580EX or 550EX is mounted in the flash shoe on the camera. The switch on the unit's foot should be set so that it functions as a master unit, and slave units are set up in the surrounding area. The light ratio of slave units can be varied manually or automatically. With E-TTL (wireless) control several different Speedlite 420EXs, 550EXs, and 580EXs can be controlled at once.

Canon's advanced flash system can balance flash with ambient light ⇨ *exposure to fill in harsh shadows and make for more natural-looking photos. ©Kara Helmkamp.*

Lenses and Accessories

The EOS 5D belongs to an extensive family of Canon EOS equipment, including lenses, flashes, and other accessories. With this wide range of available options, you could expand the capabilities of your camera quite easily should you want to. Canon has long had an excellent reputation for its lenses, and several independent manufacturers offer quality Canon compatible lenses as well. The 5D can use Canon EF lenses, ranging from wide-angle to tele-zoom, as well as single-focal-length lenses, from very wide to extreme telephoto.

Zoom lenses for the 5D range from wide-angle to tele-zoom, and Canon also offers very wide to extreme telephoto single focal length lenses. The 5D has a full-frame sensor and therefore no multiplication factor for lenses. The 30D, on the other hand, because of its smaller sensor format, multiplies both the widest angle and the farthest zoom factor by 1.6. The 5D uses focal lengths exactly the same as a 35mm film camera.

Choosing Lenses

The focal length and design of a lens will have a huge affect on how you photograph. The correct lens will make photography a joy; the wrong one will make you leave the camera at home. One approach for choosing a lens is to determine if you are frustrated with your current lenses. If you constantly want to see more of the scene than the lens will allow, consider a wider-angle lens. Or maybe the subject is too small in your photos. Then look into acquiring a zoom or telephoto lens.

◁ *You can fill the frame with a distant subject, such as this architectural detail high on the side of a building by using a telephoto lens.*

Certain subjects lend themselves to specific focal lengths. Wildlife and sports action are best photographed using focal lengths of 300mm or more, although closer action can be shot with 200mm. Portraits look great when shot with focal lengths between 80 and 100mm. Interiors often demand wide-angle lenses such as 20 or 24mm. Many people also like wide-angles for landscapes, but telephotos can come in handy for distant scenes. Close-ups can be shot with nearly any focal length, though skittish subjects such as butterflies might need a rather long lens.

These focal lengths are traditional 35mm focal lengths. However, on most digital cameras, the digital sensors are smaller than a frame of 35mm film, so they crop the area seen by the lens, essentially creating a different format. Effectively, this magnifies the subject within the image area and results in the lens acting as if it has been multiplied by a factor of 1.6 compared to the 5D, which has the same sensor size as 35mm film cameras.

Note: This is exactly the same thing that happens when one focal length is used with different sized film formats. For example, a 50mm lens is considered a mid-range focal length for 35mm, but it would be a wide-angle for medium format cameras.

Zoom vs. Prime Lenses

When zoom lenses first came on the market, they were not even close to a single-focal-length lens in sharpness, color rendition, or contrast. Today, you can get superb image quality from either type. There are some important differences, though. The biggest is maximum f/stop.

Zoom lenses are rarely as fast (e.g. rarely have as big a maximum aperture) as single focal length, or prime, lenses. A 28-200mm zoom, for example, might have a maximum aperture at 200mm of f/5.6, yet a single focal length lens might be f/4 or even f/2.8. When zoom lenses come close to

Unlike cameras with smaller sensors, the 5D's full-frame sensor pro-
duces no lens magnification factor. This is a real advantage when a
wide-angle effect is desired.

a single focal length lens in f/stops, they are usually consid-
erably bigger and more expensive than the single focal
length lens. Of course, they also offer a whole range of focal
lengths, which a single-focal-length lens cannot do. There is
no question that zoom lenses are versatile.

EF-Series Lenses

Canon EF lenses include some unique technologies. Canon
pioneered the use of tiny autofocus motors in its lenses. In
order to focus swiftly, the focusing elements within the lens
need to move with quick precision. Canon developed the
lens-based ultrasonic motor for this purpose. This technology
makes the lens motor spin with ultrasonic oscillation energy
instead of the conventional drive-train system (which tends
to be noisy). This allows lenses to autofocus nearly instantly
and with no noise (plus it uses less battery power than tradi-
tional systems). Canon lenses that utilize this motor are

labeled USM (lower-priced Canon lenses have small motors in the lenses too, but they don't use USM technology, and can be slower and noisier).

Canon was also a pioneer in the use of image-stabilizing technologies. IS (Image Stabilizer) lenses use sophisticated motors and sensors to adapt to slight movement during exposure. It's pretty amazing—the lens actually has vibration-detecting gyro stabilizers that move a special image-stabilizing lens group in response to movement of the lens. This dampens movement that occurs from handholding a camera and allows much slower shutter speeds to be used. IS also allows big telephoto lenses (such as the EF 500mm IS lens) to be used on tripods that are lighter than would normally be used with non IS telephoto lenses.

The IS technology is part of many zoom lenses, and does a great job overall. However, IS lenses in the mid-focal length ranges have tended to be slower zooms matched against single focal length lenses. For example, compare the EF-S 17-85mm f4-5.6 IS USM lens to the EF 50mm f/1.8. The former has a great zoom range, but allows considerably less light at maximum aperture. At 85mm (a good focal length for people when using the 5D), the EF 17-85mm is an f/5.6 lens, more than three stops slower than the f/1.8 single focal length lens when both are shot "wide-open" (typical of low light situations). While you could make up those three stops in "handholdability" due to the IS technology, that also means you must use two full shutter speeds slower, which can be a real problem in stopping subject movement.

With the introduction of the 30D, the 5D's "little brother," Canon also introduced a new EF-series lens. The EF 85mm f/1.2L II USM is a revision of the EF 85mm f/1.2L USM lens introduced in 1989. For the photographer who needs a longer lens with speed, this is an amazing option. Its f/1.2 maximum aperture gives it light gathering ability that few other lenses can match.

L-Series Lenses

Canon's L-series lenses use special optical technologies for high-quality lens correction. These include low-dispersion glass, fluorite elements, and aspherical designs. UD (ultra-low dispersion) glass is used in L-series telephoto lenses to minimize chromatic aberration, a common problem for telephoto lens designers. Chromatic aberration occurs when the lens can't focus all colors equally at the same point on the sensor (as well as on the film in a traditional camera). This results in less sharpness and a lot less contrast. Low-dispersion glass focuses colors more equally for sharper, crisper images.

Fluorite elements are even more effective (though more expensive) and have the corrective power of two UD lens elements. Aspherical designs are used with wide-angle and mid-focal length lenses to correct the challenges of spherical aberration in such focal lengths. Spherical aberration is a problem caused by lens elements with extreme curvature (usually found in wide-angle and wide-angle zoom lenses). Glass tends to focus light differently through different parts of such a lens, causing a slight, overall softening of the image even though the lens is focused sharply. Aspherical lenses use a special design that compensates for this optical defect.

DO-Series Lenses

A relatively recent Canon optical design is the DO, which stands for diffractive optic. This is a very promising technology that significantly reduces the size and weight of a lens, and therefore is especially useful for big telephotos and zooms. Yet, the lens quality is unchanged. The first two lenses produced by Canon in this series are a 400mm pro lens that is only two-thirds the size and weight of the equivalent standard lens, and a 70-300mm IS lens that offers a great focal length range while including image stabilization.

Macro and Tilt-Shift Lenses

Canon also makes some specialized lenses. Macro lenses are single-focal-length lenses optimized for high sharpness throughout their focus range, from very close (1:1 or 1:2) magnifications to infinity. These lenses range from 50mm to 180mm.

Tilt-shift lenses are unique lenses that shift up and down or tilt toward or away from the subject. They mimic the controls of a view camera. Shift lets the photographer keep the back of the camera parallel to the scene and move the lens to get a tall subject into the composition—this keeps vertical lines vertical and is extremely valuable for architectural photographers. Tilt changes the plane of focus so that sharpness can be changed without changing the f/stop. Focus can be extended from near to far by tilting the lens toward the subject, or sharpness can be limited by tilting the lens away from the subject.

Independent Lens Brands

Independent lens manufacturers also make some excellent lenses that fit the 5D. I've seen quite a range in capabilities from these lenses. Some include low-dispersion glass and are stunningly sharp. Others may not match the best Canon lenses, but offer features (such as focal length range or a great price) that make them worth considering. To a degree, you do get what you pay for. A low-priced Canon lens compared to a low-priced independent lens probably won't be much different. On the other hand, the high level of engineering and construction found on a Canon L-series lens can be difficult to match.

Filters and Close-Up Lenses

One myth that I have often heard today is that filters aren't needed for digital photography because adjustments for color and light can be made in the computer. That is absolutely

wrong and such an attitude can really limit a photographer's capabilities and the quality of his or her work. Using filters can actually save a substantial amount of work in the digital darkroom by allowing you to capture the desired color and tonalities for your image right from the start. Even if you can do certain things in the computer, why take the time if you can do it more efficiently while shooting?

Of course, the LCD monitor comes in handy once again. By using it, you can be sure you get the best from your filters. If you aren't sure how a filter works, you can simply try it and see the results immediately on the monitor. This is like using a Polaroid, only better, because you need no extra gear. Just take the shot, review it, and make adjustments to the exposure or white balance to help the filter do its job. If a picture doesn't come out the way you would like, you can discard and retake it right away.

Attaching filters to the camera depends entirely on your lenses. Usually, a properly sized filter can either be screwed directly onto a lens or fit into a holder that screws onto the front of the lens. There are adapters to make a given size filter fit several lenses, but the filter must cover the lens from edge to edge or it will cause dark corners in the photo (vignetting). A photographer may even hold a filter over the lens with his or her hand.

Here are a number of different types of very useful filters that perform different tasks for the digital photographer:

Polarizers
This important filter should be in every camera bag. Its effects cannot be exactly duplicated with software because it actually affects the way light is perceived by the sensor.

A polarizer darkens skies at 90° to the sun (this is a variable effect), reduces glare (which will often make colors look better), removes reflections, and increases saturation. While you can darken skies in the computer, the polarizer reduces the amount of work you have to perform in the digi-

tal darkroom. This filter will rotate in its mount, and as it rotates, the strength of the effect changes. While linear polarizers often have the strongest effect, they can cause problems with exposure, and often prevent the camera from autofocusing. Consequently, you are safer using a circular polarizer with the 5D.

Neutral Density Gray Filters
Called ND filters, this type is a helpful accessory. ND filters simply reduce the light coming through the lens. They come in different strengths, each reducing different quantities of light. Such filters give additional exposure options under bright conditions, such as a beach or snow (where a filter with a strength of 4x is often appropriate). If you like the effects when slow shutter speeds are used with moving subjects, a strong neutral density filter (such as 8x) usually works well. Of course, the great advantage of the digital camera, again, is that you can see the effects of slow shutter speeds immediately on the LCD monitor so you can modify your exposure for the best possible effect.

Graduated Neutral Density Filters
Many photographers consider this filter an essential tool. It is half clear and half dark (gray) with a graduated blending through the middle. It is used to reduce bright areas (such as sky) in tone, while not affecting darker areas (such as the ground). The computer can mimic its effects, but you may not be able to recreate the scene you wanted. A digital camera's sensor can only respond to a certain range of brightness at any given exposure, and if a part of the scene is too bright compared to the overall exposure, detail will be washed out and no amount of work in the computer will bring it back. The grad ND filter will allow you to bring that bright area down in tone so it is recorded with the proper density in the image.

UV and Skylight Filters
Though many amateur photographers buy these, pros rarely use them. The idea behind them is to give protection to the front of the lens, but they do very little visually. Still, they

can be useful when photographing under such conditions as strong wind, rain, blowing sand, or going through brush.

If you do use a filter for lens protection, a high quality filter is best. A cheap filter can degrade the image quality of the lens. Remember that the manufacturer made the lens/sensor combination with very strict tolerances. A protective filter needs to be literally invisible, and only high-quality filters can guarantee that.

Close-Up Accessories
Close-up photography is a striking and unique way to capture a scene. Most of the photographs we see on a day-to-day basis are not close-ups, making those that do make their way to our eyes all the more noticeable. It is surprising to me that many photographers think the only way to shoot close-ups is with a macro lens. The following are four of the most common close-up options:

1. **Close-focusing zoom lenses with a macro or close-focus feature**
 Most zoom lenses allow you to focus up close without accessories, although focal-length choices may become limited when using the close-focus feature. These lenses are an easy and effective way to start shooting close-ups. Keep in mind, however, that even though these may say they have a macro setting, it is really just a close-focus setting and not a true macro as described below in option four.

2. **Close-up accessory lenses**
 You can buy lenses that screw onto the front of your lens to allow it to focus even closer. The advantage is that you now have the whole range of zoom focal lengths available and there are no exposure corrections. Close-up filters can do this, but the image quality is not great. More expensive achromatic accessory lenses (highly-corrected, multi-element lenses) do a superb job with close-up work, but their quality is limited to that of the original lens.

3. **Extension tubes**

 Extension tubes fit in between the lens and the camera body. This allows the lens to focus much closer than it could normally. Extension tubes are designed to work with all lenses for your camera (although older extension tubes won't work with EF-S lenses made specifically for Canon's small-format EOS cameras, such as the 30D). Be aware that extension tubes do cause a loss of light.

4. **Macro lenses**

 Though relatively expensive, macro lenses are designed for superb sharpness at all distances and will focus from mere inches to infinity. In addition, they are typically very sharp at all f/stops.

Sharpness is a big issue with close-ups, and this is not simply a matter of buying a well-designed macro lens. The other close-up options can also give superbly sharp images. Sharpness problems usually result from three factors: limited depth of field, incorrect focus placement, and camera movement.

The closer you get to a subject, the shallower depth of field becomes. You can stop your lens down as far as it will go for more depth of field, or use a lens with a wider angle, but depth of field will still be limited. Because of this, it is critical to be sure focus is placed correctly on the subject. If the back of an insect is sharp but its eyes aren't, the photo will appear to have a focus problem. At these close distances, every detail counts. If only half of the flower petals are in focus, the overall photo will not look sharp. Autofocus up close can be a real problem with critical focus placement because the camera will often focus on the wrong part of the photo.

Of course, you can review your photo on the LCD Monitor to be sure the focus is correct before leaving your subject. You can also try manual focus. One technique is to focus the lens at a reasonable distance, then move the camera toward and away from the subject as you watch it go in and out of focus. This can really help, but still, you may find that taking multiple photos is the best way to guarantee

144

proper focus at these close distances. Another good technique is to shoot on the continuous drive mode and fire multiple photos. You will often find at least one shot with the critical part of your subject in focus. This is a great technique when you are handholding and when you want to capture moving subjects.

When you are focusing close, even slight movement can shift the camera dramatically in relationship to the subject. The way to help correct this is to use a high shutter speed or put the camera on a tripod. Two advantages to using a digital camera during close-up work are the ability to check the image to see if you are having camera movement problems, as well as the ability to change ISO settings from picture to picture to enable a faster shutter speed if you deem it necessary.

The best looking close-up images will often be ones that allow the subject to contrast with its background, making it stand out and adding some drama to the photo. There are three important contrast options to keep in mind. They apply to any photograph where you want the subject to stand out, but they can be easily applied to close-up subjects where a slight movement of the camera can totally change the background.

There are three important contrast options to keep in mind:

1. **Tonal or brightness contrasts**
 Look for a background that is darker or lighter than your close-up subject. This may mean a small adjustment in camera position. Backlight is excellent for this since it offers bright edges on your subject with lots of dark shadows behind it.

2. **Color contrasts**
 Color contrast is a great way to make your subject stand out from the background. Flowers are popular close-up subjects and, with their bright colors, they are perfect candidates for this type of contrast. Just look for a background that is either a completely different color (such

as green grass behind red flowers) or a different saturation of color (such as a bright green bug against dark green grass).

3. **Sharpness contrast**

One of the best close-up techniques is to work with the inherent limit in depth of field and deliberately set a sharp subject against an out-of-focus background or foreground. Look at the distance between your subject and its surroundings. How close are other objects to your subject? Move to a different angle so that distractions are not conflicting with the edges of your subject. Try different f/stops to change the look of an out-of-focus background or foreground.

Tripods and Camera Support

In order to get the most from a digital camera, you need to be aware that camera movement can affect sharpness and tonal brilliance in an image. Even slight movement during the exposure can cause the loss of fine details and the blurring of highlights. These effects are especially glaring when you compare an affected image to a photo that has no motion problems. In addition, affected images will not enlarge well.

You must minimize camera movement in order to maximize the capabilities of your lens and sensor. A steady hold on the camera is a start. Fast shutter speeds, as well as the use of flash, help to ensure sharp photos, although you can get away with slower shutter speeds when using wider-angle lenses. However, when shutter speeds go down, it is advisable to use a camera-stabilizing device. Tripods, beanbags, monopods, mini-tripods, shoulder stocks, clamps, and more all help. Many photographers carry a small beanbag or a clamp pod with their camera equipment for those situations where the camera needs support but a tripod isn't available. There is even a beanbag on the market with a tripod screw so it can be attached to your camera.

Check your local camera store for the variety of stabilizing equipment. A good tripod is an excellent investment. When buying a tripod, extend it all the way to see how easy it is to open, then lean on it to see how stiff it is. Both aluminum and carbon fiber tripods offer great rigidity. Carbon fiber is much lighter, but also more expensive.

The head is a very important part of the tripod and may be sold separately. There are two basic types for still photography: the ball head and the pan-and-tilt head. Both designs are capable of solid support and both have their passionate advocates. The biggest difference between them is how you loosen the controls and adjust the camera. Try both and see which seems to work better for you. Be sure to do this with a camera on the tripod because that added weight changes how the head works.

THE BENCHES AND URN ERECTED BY
CAROLINE STECHER SCHLEGEL
IN MEMORY OF HER MOTHER
CAROLINE WURTZ STECHER
BELOVED WIFE OF HENRY STECHER

Working with Your Images

Camera to Computer

You've been out shooting and your memory card is full of images. Now what? There are two main ways to copy digital files from the memory card into the computer. You can download images by connecting the 5D to your computer using the USB interface cable (IFC-400PCU) included with the camera. The other way is to insert the card into an accessory card reader.

The advantage of downloading directly from the camera is that there is nothing to buy. Canon supplies the necessary connection cord and software. However, there are some disadvantages to using this method. For one, the download time will be longer. The camera has to be unplugged from the computer after each use (the card reader can be left attached). Downloading directly from the camera requires battery power. You may lose images if the battery runs down while images are transferring.

To connect the camera, first select Communication from the Set-up menu ¶¶ and set it to PC connect. Turn the camera off and connect it to the computer with the interface cable. Turn the camera on and the CameraWindow icon will appear in the dock on your computer. (CameraWindow is Canon software supplied with the 5D.) This indicates that a connection has been made between the camera and computer. You can then click the CameraWindow icon and use the software to download images from the camera.

◁ *You've been out shooting and now you want to view the images on your computer. Download images from the EOS 5D either by connecting the camera directly to the computer using the supplied USB cord or a CF compatible card reader.*

Note: To transfer images directly from the camera, you must have the software supplied with your 5D installed on your computer.

 Card readers connect to your computer through a USB or FireWire port and can remain plugged in and ready to download your pictures. FireWire, if you have that capability on your computer, is faster than USB, which has two types: USB 1.1 and 2.0. Older computers and card readers will use 1.1, but new devices use the faster 2.0 connection.

 Card readers are available at computer stores and from most electronics stores. There are several different types, including single-card readers that read only one particular type of memory card, or multi-readers that are able to utilize several different kinds of cards. For the 5D, you only need a card reader for CompactFlash cards, but if you have other cameras (or intend to purchase other cameras) you will want a multi-card reader. The price difference is negligible. After your card reader is connected to your computer, remove the memory card from your camera and put it into the appropriate slot in your card reader. The card will usually show up as an additional drive on your computer. (You may have to install a driver that comes with the card reader.) Typically you can just open the drive, select the image files, and copy them to a folder on your hard drive.

Organizing Image Files

Do you edit and file your digital photos so that they are accessible and easy to use? If you don't get in the habit of organizing your photo files, it can cause problems for you. You'll waste time looking for images, you'll waste storage space on your computer by saving unwanted or duplicate files, and you may even lose or delete important images.

 Be sure to edit your photos and remove extraneous shots. Some photographers review their pictures as they shoot and delete the ones that are obviously unacceptable. Others wait

Your computer's hard drive can quickly become cluttered with digital photos if you do not develop an organizational system. This includes naming files, setting up a folder hierarchy, and using a reliable backup system.

and evaluate photos once they are downloaded to the computer. Unwanted photos take up space on your hard drive, so you should store only the ones you intend to keep.

When you download images from your CF card, you'll want to organize them into folders. Create a parent folder with a name like Photos or Images. Within this folder, create folder to categorize images i.e., Vacations, Portraits, Work, Stock Photography. You may even need to create folders within these folders to group images.

Here's how I deal with digital camera files. I use a memory card reader that shows up as a drive on my computer. I open the memory card as a window or open folder and I open the folder named Digital Images on the computer's hard drive. I create a new subfolder within the Digital Images folder and give it a name appropriate to the subject matter on the memory card. I select all the images in the

memory card folder and transfer them to the new subfolder I
have created for them. This is really no different than setting
up an office filing cabinet with hanging folders or envelopes
to hold photos. Consider the Digital Images folder to be the
file cabinet, and the individual folders inside to be the
equivalent of the file cabinet's hanging folders. Actually, a
digital filing system is better than using a physical filing cab-
inet. I don't have to physically sort through folders. I can
have the computer search out images for me.

Once you have downloaded your images onto the com-
puter, I suggest you burn them to a CD or DVD as soon as
possible. Everyone knows computers can crash and files can
become corrupted. If your images are only stored on your
hard drive, you run the risk of losing your images. You don't
want copies of an important photo project to be stored
exclusively on your computer. Set up a backup system. I
think CDs work well, other methods are described in the
"Storing Your Images" section.

Image Browser Programs

A good image browser program is crucial for organizing
large quantities of images. These programs allow you to
quickly look at photos on your computer, edit them, rename
photos one at a time or all at once, read all major files,
move photos from folder to folder, resize photos for e-mail-
ing, create simple slideshows, and more. Most browser pro-
grams include some database functions, allowing you to tag
images with keywords for searching and sorting. There are
good, feature-rich programs for both Windows and Macin-
tosh platforms.

One feature that I really like in a browser program is the
ability to print customized index prints. You can then give a
title to each of these index prints, and also list additional
information about the photo. The index print is a hardcopy
that allows easy reference and visual searches. You could
include an index print with every CD you burn so you can
quickly see what is on the CD and find the file you need. A
combination of organized, well-labeled file folders on your

hard drive, a browser program, and a backup system with index prints will help you to maintain your image library.

Canon supplies its own program, ZoomBrowser for Windows or ImageBrowser for Macintosh, with the EOS 5D. This program is very easy-to-use with most of the features required of a good image browser. There are multiple ways to preview, sort, and display photos. The image editing feature gives the user a great deal of control and functionality, including the ability to process RAW files. However, if you're looking for another Image Browser, there are many options to help view and organize your images. ACDSee is a superb program with a customizable interface, keyboard tagging of images, and some unique characteristics such as a calendar feature that lets you find photos by date. (Unfortunately, the most full-featured version is Windows only.) Another very good program with similar capabilities is iView Media (with equal features on both Windows and Mac versions). Adobe realized the browser built into Photoshop wasn't enough for most photographers, so they developed Adobe Bridge. The real strength of this program is the way it integrates with other programs in Adobe's Creative Suite. You may also want to check out Digital PhotoPro, which was designed by professional photographers and has some interesting pro features, including a digital magnifying loupe.

Image Processing

Of course, you can process the 5D's JPEG files in any image-processing program. One nice thing about JPEG is that it is one of the most universally available formats. Any program on any computer that recognizes image files will recognize JPEG. The EOS 5D uses settings, such as Picture Styles, to get the most from the JPEG format with minimal post-processing. JPEG files can be adjusted later in the computer to get more out of them.

While RAW files offer more capacity for change, you can still do a lot with a JPEG file to optimize it for use. I shoot

mainly JPEG for my professional work because it fits the workflow processes I have developed for myself, and no clients complain about the quality of my images.

RAW is an important format because it leaves all your adjustment options available to you. As we've described before, the image data in a RAW file is unadulterated. RAW conversion programs read the file's metatdata (shooting information stored by the camera) when opening an image. You can then change these exposure values without causing harm to the file. Most RAW software allows batch processing. This allows you to adjust a group of photos to specific settings and can be a very important way to deal with multiple photos from the same shoot. In addition, Canon's new RAW file, CR2, offers increased flexibility and control over the image.

The big advantage to the RAW file is that it captures more directly what the sensor sees. It holds more information (12-bits vs. the JPEGs 8-bits per color) and can have stronger correction applied to it (compared to JPEG images) before the image quality starts to degrade. This can be particularly helpful when there are difficulties with exposure or color balance. (Remember that the image file from the camera holds 12-bits of data even though it is contained in a 16-bit file. While you can create a 16-bit TIFF file from the RAW file, it is based on 12 bits of data.)

Note: 5D RAW files are nearly 13 MB in size, so they will fill memory cards quite quickly. In addition, they can increase processing and workflow times.

Companies are beginning to listen to the needs of photographers where RAW files are concerned. RAW files were often considered "difficult" to work with because they required proprietary software. The latest software supplied by Canon has many options for converting CR2 files to standard files (TIFF or JPEG) and also for transferring files to other image-processing programs. In addition, the latest version of Photoshop has a RAW file converter (ACR or Adobe Camera RAW) built-in;

The EOS 5D is supplied with Canon's own image browser software. You can download images from the camera and also use it to organize and view images on your computer.

for earlier versions there are plug-ins available. There is a slight quality difference between using these and using the Canon software, which after all was created specifically for Canon's proprietary RAW file. However, the difference is small. Whichever method you choose to gain access to RAW files in your computer, you will have excellent control over your images in terms of exposure and color.

Digital Photo Professional Software

Digital Photo Professional (DPP) was developed to bring Canon RAW file processing up to speed with the rest of the digital world. (Even Canon admitted the File Viewer Utility did not have the power of competitive programs, yet it was their only RAW conversion program.) This program, supplied with the EOS 5D, has a brand-new processing engine and is loaded with features, including color management, file conversion, batch processing and printing. It will work with files from many Canon cameras, including EOS-1D series, the

Digital Rebel models, and of course, the 5D. It can be used to process CR2 files, CRW files (Canon's previous RAW format), TIFF files, and JPEG files. The advantage to processing JPEG files is that DPP is quicker and easier to use than Photoshop, yet is still quite powerful. So for fast and simple JPEG processing, DPP works quite well and if you are going to shoot RAW, this is a must-use program. It is fast, full-featured, and gives excellent results.

Storing Your Images

If your image files are only stored on your computer's hard drive you are asking for trouble. Putting files in a duplicate folder on your hard drive will not protect you. Your images can be lost or destroyed if you do not create proper backup files.

Many photographers use two hard drives, either adding a second one to the inside of the computer or using an external USB or FireWire drive. This allows you to immediately and easily back-up photos on the second drive. Using a portable external drive makes it easy to bring images with you, such as to client meetings. Hard drives do a great job of recording image files for processing, transmitting, and sharing, but they are not ideal for long-term storage. Magnetic media, such as a hard drives, have a limited lifespan and these devices have been known to lose data within ten years. Also, there are a number of malicious computer viruses that can wipe out a hard drive. Even the best drives can crash, rendering them unusable. Plus, we are all capable of accidentally erasing or saving over an important photo.

For more permanent backup, it is recommended that you burn your images to optical media: CDs or DVDs. A CD writer or "burner" is a necessity for the digital photographer. DVD writers work extremely well, too, and DVDs can handle about six times the data that can be saved on a CD. Either option allows you to back up photo files and store images safely.

There are two types of CDs that can be used for recording data: CD-R disks are recordable and CD-RW disks are rewritable. CD-R disks can only be recorded once—they cannot be erased and no new data can be added to them. CD-RWs allow you to record data, add data, erase data, and reuse the disks.

DVDs also have recordable and rewriteable versions. DVDs are not as universal as CDs however. DVD burners accept either DVD-R and DVD-RW or DVD+R and DVD+RW disks. Check the specifications of your DVD burner before you purchase DVDs.

For long-term storage of your images, use recordable optical media rather than rewritable. (The latter is best used for temporary storage.) Recordable disks are more stable than rewritable disks (which makes sense since CD-RWs or DVD-RWs are designed to be erasable). Buy quality media. Inexpensive disks may not preserve your photo-image files as long as you would like them to. Read the box. Look for information about the life of the disk. Most long-lived disks are labeled as such and cost a little more.

Memory cards should not be used for image backup. They do not make a cost-effective storage system and they are easily erased or reformatted. Also, because they are magnetic media, the data may degrade as the card ages.

Direct Printing

With certain compatible printers, you can control the printing directly from the EOS 5D. Simply connect the camera to the printer using the interface cable supplied with the camera or the dedicated USB cord that came with the printer. In addition to Canon printers, the EOS 5D camera is PictBridge compatible. This means that it can be directly connected to PictBridge printers from other manufacturers. Nearly all new photo printers are PictBridge compatible.

Note: RAW files cannot be used for the direct printing options mentioned in this section.

You must first set the camera to communicate with the printer. In the Set-up menu ⚏ select Communications and set it to PTP/Print. Next, making sure that both the camera and the printer are turned off, connect the camera to the printer with the camera's interface cable. Turn on the printer first and then the camera. This sequence is important; it ensures that the camera recognizes the printer and is prepared to control it.

Press the Playback button ▶ and an image will appear as well as a printer icon in the upper left corner. (The printer icon will vary depending on the type of printer connected: PictBridge, Bubble Jet Direct, or CP Direct.) Use the Quick Control Dial ⊙ to select an image that you want to print. Press the Set button ⚏ and the Print Setting screen will appear, giving such printing choices as whether to imprint the date, quantity, and paper settings (size, type, borders or borderless). There is an effect setting that provides minimal control over image color and trimming allows you to crop your photo so a section of the image fills the print. Scroll through the various options using the ⊙ and press the ⚏ to input the desired settings. These choices may change depending on the printer; refer to the printer's manual if necessary.

Note: The amount of control you have over the image when printing directly from the camera is limited entirely by the printer, and often you will have little or no control over color and brightness. If your images need correction, print from the computer.

If you are shooting a lot of images for which you plan to use direct printing, do some test shots and set a Picture Style to optimize the prints before actually shooting the final pictures. You may even want to create a User Defined setting that increases sharpness and saturation just for this purpose.

Digital Print Order Format (DPOF)

Another printing feature of the 5D is DPOF (Digital Print Order Format). This allows you to decide which images to print before you actually do any printing. Then, if you have a printer that recognizes DPOF, it will print those specifically chosen images automatically. This feature will also tag images for printing at a photo lab. When you drop off your CF card, the lab will know which images you want printed and the quantity for each print, assuming the lab's equipment recognizes DPOF. (It is a very common feature, but you should ask before you leave your card.)

DPOF is accessible through the Playback menu ▶ under Print Order. Select Set Up to choose Print Type (standard/index/both), Date (on/off), and File No. (on/off). Print Type selects either a single image per print or multiple thumbnails on a print. Date and File No. settings add this information to your prints. You can set the options you want, choosing all or any combination of individual images. After setting up your choices, press the Menu button to return to Print Order. From there, select either Order or All. Order allows you to use the Quick Control Dial ◎ to select which individual images you want to print, along with their quantity (All selects all the images on the card for printing). RAW files cannot be tagged for DPOF printing.

Glossary

aberration
An optical flaw in a lens that causes the image to be distorted or unclear.

Adobe Photoshop
Professional-level image-processing software with extremely powerful filter and color-correction tools. It offers features for photography, graphic design, web design, and video.

Adobe Photoshop Elements
A photo-processing program based on the processing _engine_ of Photoshop (though it has a different interface and set of controls). The Elements program lacks some of the more sophisticated controls available in Photoshop, but it does have a comprehensive range of image-manipulation options.

AE
See automatic exposure.

AF
See automatic focus.

AI
Automatic Indexing.

ambient light
See available light.

angle of view
The area seen by a lens, usually measured in degrees across the diagonal of the film frame.

anti-aliasing
A technique that reduces or eliminates the jagged appearance of lines or edges in an image.

aperture
The opening in the lens that allows light to enter the camera. Aperture is usually described as an f/number. The higher the f/number, the smaller the aperture; and the lower the f/number, the larger the aperture.

Aperture-Priority mode
A type of automatic exposure in which you manually select the aperture and the camera automatically selects the shutter speed for the appropriate exposure.

artifact
Information that is not part of the scene but appears in the image due to technology. Artifacts can occur in film or digital images and include grain, flare, static marks, color flaws, noise, etc.

artificial light
Usually refers to any light source that doesn't exist in nature, such as incandescent, fluorescent, and other manufactured lighting.

automatic exposure
When the camera measures light and makes the adjustments necessary to create proper image density on sensitized media.

automatic flash
An electronic flash unit that reads light reflected off a subject (from either a preflash or the actual flash exposure), then shuts itself off as soon as ample light has reached the sensitized medium.

automatic focus
When the camera automatically adjusts the lens elements to sharply render the subject.

Av
Aperture Value. See Aperture-priority mode.

available light
The amount of illumination at a given location that applies to natural and artificial light sources but not those supplied specifically for photography. It is also called existing light or ambient light.

backlight
Light that projects toward the camera from behind the subject.

backup
A copy of a file or program made to ensure that, if the original is lost or damaged, the necessary information is still intact.

barrel distortion
A defect in the lens that makes straight lines curve outward away from the middle of the image – most noticeable toward the edges of the frame.

bit
Binary digit. This is the basic unit of binary computation. See also, byte.

bit depth
The number of bits per pixel that determines the number of colors the image can display. Eight bits per pixel is the minimum requirement for a photo-quality color image.

bounce light
Light that reflects off of another surface before illuminating the subject.

bracketing
A sequence of pictures taken of the same subject but varying one or more exposure settings, manually or automatically, between each exposure.

brightness
A subjective measure of illumination. See also, luminance.

buffer
Temporarily stores data so that other programs or operations, on the camera or the computer, can continue to run while data is in transition.

built-in flash
A flash that is permanently attached to the camera body. The built-in flash will pop up and fire in low-light situations when using the camera's automated exposure settings.

built-in meter
A light-measuring device that is incorporated into the camera body.

bulb
A camera setting that allows the shutter to stay open as long as the shutter release is depressed.

byte
A measurement of computer data; a single group of eight bits that is processed as one unit. See also, bit.

card reader
Device that connects to your computer and enables quick and easy download of images from memory card to computer.

CCD
Charge Coupled Device. This is a light sensitive sensor type common to many digital cameras. It is sensitized by applying an electrical charge to the sensor prior to its exposure to light. It converts light energy into an electrical impulse.

chromatic aberration
Occurs when light rays of different colors are focused on different planes, causing colored fringing or halos around objects in the image.

chrominance
A component of an image that expresses the color (hue and saturation) information, as opposed to the luminance (lightness) values.

close-up
A general term used to describe an image created by closely focusing on a subject. Often involves the use of special lenses or extension tubes.

CMOS
Complementary Metal Oxide Semiconductor. Like CCD sensors, this type of light sensitive sensor is sensitized from an electric change and converts light into an electrical impulses. CMOS sensors are less expensive to produce than CCD sensors, and use less power. See also, CCD.

CMYK mode
Cyan, magenta, yellow, and black. This mode is typically used in image-editing applications when preparing an image for commercial printing.

color balance
The average overall color in a reproduced image; how a digital camera interprets the color of light in a scene so that white or neutral gray

appear neutral.

color cast
A colored hue over the image often caused by improper lighting or incorrect white balance settings. Can be produced intentionally for creative effect.

color space
A mapped relationship between colors and computer data about the colors.

CompactFlash (CF) card
One of the most widely used memory cards.

complementary colors
In theory: any two colors of light that, when combined, emit all known visible light wavelengths, resulting in white light. Also, it can be any pair of dye or pigment colors that absorb all known light wavelengths, resulting in black.

compression
A method of reducing file size through removal of redundant data, as with the JPEG file format.

contrast
The difference between two or more tones in terms of luminance, density, or darkness.

contrast filter
A colored filter that lightens or darkens the monotone representation of a colored area or object in a black-and-white photograph.

critical focus
The most sharply focused plane within an image.

cropping
The process of extracting a portion of the image area. If this portion of

the image is enlarged, pixels are spread out, effectively lowering resolution.

dedicated flash
An electronic flash unit that talks with the camera, communicating things such as flash illumination, lens focal length, subject distance, and sometimes flash status.

default
Refers to various factory-set attributes or features, which in the case of a camera, includes controls that can be changed by the user but can, as desired, be reset to the original factory settings.

depth of field
The image space in front of and behind the plane of focus that appears acceptably sharp in the photograph -- the sharpness in depth from front to back in an image.

diaphragm
A mechanism that determines the size of the lens opening that allows light to pass into the camera when taking a photo.

diopter
A measurement of the refractive power of a lens element -- this is typically used to identify the amount of correction at the eyepiece to allow the photographer to better see the viewfinder. Also, it may be a supplementary lens that is defined by its focal length and power of magnification.

download
The transfer of data from one device to another, such as from camera to computer or computer to printer.

dpi
Dots per inch. Used to define the resolution of a printer, this term refers to the number of dots of ink that a printer can lay down in an inch. It is commonly used interchangeably with PPI, because it also refers to the pixels in a scanner; in that case, it is then directly related to the pixels in an image.

DPOF
Digital Print Order Format. A feature that enables the camera to supply data about the printing of image files and supplementary information contained within them – usually used by photo labs. The lab's printer must be DPOF compatible for the system to operate.

dye sublimation printer
Creates color on the printed page by vaporizing inks that then solidify on the page.

electronic flash
A device with a glass or plastic tube filled with gas that, when electrified, creates an intense, short flash of light.

electronic rangefinder
A system that utilizes the AF technology built into a camera to provide a visual confirmation that focus has been achieved. It can operate in either manual or AF focus modes.

EV
Exposure value. A number that quantifies the amount of light within a scene, allowing you to determine the relative combinations of aperture and shutter speed to accurately reproduce the light levels of that exposure.

EXIF
Exchangeable Image File Format. A type of metadata (data attached to a file that describes the file) used for storing digital image information with that file, such as camera type, exposure, focal length and more.

exposure
When light enters a camera and reacts with the sensitized medium. It also refers to the amount of light that strikes the sensitized medium.

exposure meter
See light meter.

extension tube
A hollow metal ring that can be fitted between the camera and lens (it usually includes mechanical and electronic connectors so the camera and lens still work normally). It increases the distance between the optical center of the lens and the sensor and allows the lens to focus closer.

FAT
File Allocation Table. This is a method used by computer operating systems to keep track of files stored on the hard drive.

file format
The form in which digital images are stored and recorded, e.g., JPEG, RAW, TIFF, etc.

filter
A piece of plastic or glass used to control how certain wavelengths of light are allowed through the lens. A filter absorbs selected wavelengths, preventing them from reaching the sensitized medium. Also, filter refers to software available in image-processing computer programs that produce special effects.

FireWire
A high speed data transfer standard that allows outlying accessories to be plugged and unplugged from the computer while it is turned on. Some digital cameras and card readers use FireWire to connect to the computer. FireWire transfers data much faster than USB 1.0 and has a similar speed to USB 2.0. See also, Mbps.

firmware
Software that is incorporated into a hardware chip. All computer-based equipment, including digital cameras, use firmware of some kind.

flare
Unwanted light streaks or rings in an image caused by bright light entering the lens and camera during shooting and bouncing around inside the lens. Diffuse flare is uniformly reflected light that can lower the contrast of the image. Zoom lenses are especially susceptible to flare because they are comprised of many elements. Filters can also increase flare. Use of a lens hood can often reduce this undesirable effect.

f/number
See f/stop.

focal length
The distance from the optical center of the lens to the focal plane when the lens is focused on infinity.

focal plane
The plane on which a lens forms a sharp image. Also, it may be the film plane or sensor plane.

focus
An optimum sharpness or image clarity that occurs when a lens creates a sharp image by converging

light rays to specific points at the focal plane. The word also refers to the act of adjusting the lens to achieve optimal image sharpness.

FP high-speed sync
Focal Plane high-speed sync. This allows flash units to be synchronized at shutter speeds higher than the standard sync speed. In this flash mode, the level of flash output is reduced and, consequently, the shooting range is reduced.

f/stop
The size of the aperture or diaphragm opening of a lens, also referred to as f/number or stop. The term stands for the ratio of the focal length (f) of the lens to the width of its aperture opening -- while this ratio actually is a fraction, the f-stop number does not use a fraction, but simply the denominator, which is why f/2.8 is a wide opening (1/2.8) compared to f22 being a narrow opening (1/22). Each stop up (lower f/number) doubles the amount of light reaching the sensitized medium. Each stop down (higher f/number) halves the amount of light reaching the sensitized medium.

full-frame
The maximum area of the sensitized medium (film or sensor) that can capture the image from the lens. Also used to refer to full-frame sensor

full-frame sensor
A sensor in a digital camera that has the same dimensions as a 35mm film frame (24 x 36 mm).

GB
See gigabyte.

gigabyte
Just over one billion bytes.
GN
See guide number.

gray card
A card used to take accurate exposure readings and sometimes used for color balance correction. It typically has a gray side that reflects 18% (which is visually middle gray) and a white side that reflects 90% of the light.

gray scale
A successive series of tones ranging between black and white, which have no color.

guide number
A number used to quantify the output of a flash unit. It is derived by using this formula: GN = aperture x distance. Guide numbers are expressed for a given ISO film speed in either feet or meters.

hard drive
A contained storage unit made up of magnetically sensitive disks.

histogram
A graphic representation of image brightness levels.

hot shoe
An electronically connected flash mount on the camera body. It enables direct connection between the camera and an external flash, and synchronizes the shutter release with the firing of the flash.

icon
A symbol used to represent a file, function, or program.

image-editing program
See image-processing program

image-processing program
Software that allows for image adjustment, alteration and enhancement.

infinity
In photographic terms, a theoretical most distant point of focus.

interpolation
Process used to increase image resolution by creating new pixels based on existing pixels. The software intelligently looks at existing pixels and creates new pixels to fill the gaps and achieve a higher resolution.

IS
Image Stabilization. This is a technology that reduces the effect of camera shake and vibration. It is used in lenses, binoculars, camcorders, etc. Canon uses the IS name; Nikon's is Vibration Reduction; and Sigma has chosen Optical Stabilization.

ISO
A term for industry standards from the International Organization for Standardization. When an ISO number is applied to film, it indicates the relative light sensitivity of the recording medium. Digital sensors use film ISO equivalents, which are based on enhancing the data stream or boosting the signal.

JPEG
Joint Photographic Experts Group. This is an intelligent, though lossy compression file format that works with any computer and photo software. JPEG smartly examines an image for redundant information, removes it to create a smaller file for storage, then rebuilds the data later when the file is opened in the computer. It is a variable compression format because the amount of data in the file depends on the detail in the photo and the amount of compression. At low compression/high quality, the loss of data has a negligible effect on the photo. However, JPEG should not be used as a working format; the file should be reopened and saved in a format such as TIFF, which does not compress the image.

KB
See kilobyte.

kilobyte
Just over one thousand bytes.

LCD
Liquid Crystal Display; a flat screen with two polarizing sheets on either side of a liquid crystal solution. When activated by an electric current, the LCD uses the crystals to either pass through or block light, creating a black-and-white or colored image.

LED
Light Emitting Diode. It is a light often employed as an indicator on cameras as well as on other electronic equipment.

lens
The optics in front of a camera that have been designed for photo use with multiple glass elements to control angle of view (focal length) and to create sharp images on the sensor or film.

lens hood
Also called a lens shade. This is a short tube that can be attached to the front of a lens to reduce flare. It keeps undesirable light from reaching the front of the lens and also protects the front of the lens.

lens shade
See lens hood.

light meter
Also called an exposure meter, it is a device that measures light levels and calculates the correct aperture and shutter speed.

lithium-ion
A popular battery technology (sometimes abbreviated to Li-ion) that is not prone to the charge memory effects of nickel-cadmium (Ni-Cd) batteries or the low temperature performance problems of alkaline batteries.

long lens
See telephoto lens.

lossless
Image compression in which no data is lost.

lossy
Image compression in which data is lost and, thereby, image quality may be lessened. This means that the greater the compression, the lesser the image quality.

luminance
A term used to describe brightness. See also, brightness, chrominance, and noise.

luminance noise
A form of noise that appears as a sprinkling of black and white "grain" in an image.

M
See Manual exposure mode.

macro lens
A lens designed to be at top sharpness when focused at close distances and reproduction ratios up to 1:1.

main light
The primary or dominant light source. It influences texture, volume, and shadows.

Manual exposure mode
A camera operating mode that requires the user to determine and set both the aperture and shutter speed. This is the opposite of automatic exposure.

MB
See megabyte.

Mbps
Megabits per second. This unit is used to describe the rate of data transfer. See also, megabit.

megabit
One million bits of data. See also, bit.

megabyte
Just over one million bytes.

megapixel
A million pixels.

memory
The storage capacity of a hard drive or other recording media.

memory card
A solid state removable storage medium used in digital devices. They can store still images, moving images, or sound, as well as related file data. There are several different types, including CompactFlash, xD,

SD, or Sony's proprietary Memory Stick, to name a few. Individual card capacity is limited by available storage as well as by the size of the recorded data (determined by factors such as image resolution and file format). See also, CompactFlash (CF) card, file format.

menu
A listing of features, functions, or options displayed on a screen that can be selected and activated by the user.

middle gray
Visually halfway between black and white, it is an average gray tone with 18% reflectance. See also, gray card.

midtone
Any tone that appears as a medium brightness, or a medium gray tone, in a photographic image.

mode
Specified operating conditions of the camera or software program.

Moiré
A moiré pattern occurs because the _frequency_ of detail in a scene conflicts with the resolution on a sensor. Moiré appears as a wavy pattern over the image.

noise
The digital equivalent of grain. It is often caused by a number of different factors, such as a high ISO setting, long exposures, heat, sensor design, etc. Though usually undesirable, it may be added for creative effect using an image-processing program. See also, chrominance noise and luminance noise.

normal lens
See standard lens.

operating system (OS)
The system software that provides the environment within which all other software operates.

overexposed
When too much light is recorded with the image, causing the photo to be too light or washed out in tone.

pan
Moving the camera to follow a moving subject. When a slow shutter speed is used, this creates an image in which the subject appears sharp and the background is blurred.

perspective
The effect of the distance between the camera and image elements upon the perceived size of objects in an image. It is also an expression of this three-dimensional relationship in two dimensions.

pixel
Derived from picture element. A pixel is the base component of a digital image. Every individual pixel can have a distinct color and tone.

plug-in
Third-party software created to augment an existing software program and must work within that host software.

polarization
An effect achieved by using a polarizing filter. It minimizes reflections from non-metallic surfaces like water and glass and saturates colors by removing glare. Polarization

often makes skies appear bluer at 90 degrees to the sun. The term also applies to the above effects simulated by a polarizing software filter.

pre-flash
Short duration, low intensity flash pulse emitted by a flash unit immediately prior to the shutter opening. This allows the TTL light meter to assess the reflectivity of the subject and determine flash exposure. See also, TTL.

Program mode
In Program exposure mode, the camera selects a combination of shutter speed and aperture automatically.

RAM
Stands for Random Access Memory, which is a computer's memory capacity, directly accessible from the central processing unit.

RAW
An image file format that uses a maximum amount of information from the sensor with minimal processing applied by the camera. It contains 12-bit color information, a wider range of data than 8-bit formats such as JPEG.

RAW+JPEG
A camera recording choice that records two files per capture: one RAW file and one JPEG file.

rear curtain sync
A feature that causes the flash unit to fire just prior to the shutter closing.

resolution
The amount of data available for an image as applied to image size. It is

expressed in pixels or megapixels, or in pixels per inch (ppi) which affects how an image can be used.

RGB mode
Red, Green, and Blue. This is the color model most commonly used to display color images on video systems and computer monitors. It displays all visible colors as combinations of red, green, and blue. RGB mode is the most common color mode for viewing and working with digital files onscreen.

saturation
The intensity of a color as it changes from the neutral, grey tone; low saturation produces whereas high saturation gives pure color.

sharp
A term used to describe the quality of an image as clear, crisp, and perfectly focused, as opposed to fuzzy, obscure, or unfocused.

short lens
A lens with a short focal length -- a wide-angle lens. It produces a greater angle of view than a normal lens.

shutter
The apparatus that controls the amount of time during which light is allowed to reach the film or sensor.

Shutter-Priority mode
An automatic exposure mode in which you manually select the shutter speed and the camera automatically selects the aperture for proper exposure.

Single-lens reflex
See SLR.

slow sync
A flash mode in which a slow shutter speed is used with the flash in order to allow ambient light to be recorded by the sensor along with the flash.

SLR
Single-lens reflex. A camera with mirror that reflects the image from the single lens onto the viewfinder screen. A pentaprism or pentamirror then allows you to see that screen through the eyepiece. When you take the picture, the mirror out of the way, the focal plane shutter opens, and the image is recorded.

small-format sensor
In digital cameras, this type of sensor is physically smaller than the 35mm film frame. The result is that the same lens covers a smaller angle of view than on a 35mm camera. In effect, they act like longer lenses. This is because the sensor crops the area that would be seen by the full-frame 35mm and the same lens. The effect is that the subject is magnified within the image area, giving the sensor a "magnification factor" to give an equivalent focal length comparison.

standard lens
Also known as a normal lens, this is a fixed-focal-length lens usually in the range of 45 to 55mm for 35mm format (or the equivalent range for small-format sensors). Compared to wide-angle or telephoto lenses, a standard lens views a scene with a realistically proportionate perspective.

stop down
To reduce the size of the diaphragm (lens) opening by setting a higher f/number.

Open up
To increase the size of the diaphragm (lens) opening by setting a lower f/number.

strobe
Abbreviation for stroboscopic. An electronic light source that produces a series of evenly spaced bursts of light. Often used to refer to any electronic flash.

synchronize
When the flash exposes the sensor (or film) correctly because the flash unit fires simultaneously with the complete opening of the camera's shutter.

telephoto effect
When objects in an image appear closer than they really are through the use of a telephoto lens; a flattening of perspective.

telephoto lens
A lens with a long focal length that enlarges the subject and produces a narrower angle of view than you would see with your eyes.

thumbnail
A small representation of an image file used principally for identification purposes.

TIFF
Tagged Image File Format. This popular digital format uses no compression, is a ubiquitous format that both Mac and Windows platforms recognize, and will not affect the image when opened and resaved repeatedly.

tripod
A three-legged stand that stabilizes the camera and eliminates camera shake caused by body movement or vibration. Tripods are usually adjustable for height and angle.

TTL
Through-the-Lens, i.e. TTL metering.

Tv
Time Value. See Shutter-Priority mode.

USB
Universal Serial Bus. This interface standard allows outlying accessories to be plugged and unplugged from the computer while it is turned on. USB 2.0 enables high-speed data transfer.

vignetting
A reduction in light at the edges or corners of an image, darkening them. This can be caused by lens aberrations, too large a filter or an inappro-

priate lens hood. This can also occur by using a small-format lens on a larger-format digital camera.

viewfinder screen
The ground glass surface on which you view an image in a digital SLR.

wide-angle lens
A lens that lets you see a scene with an angle of view wider than the typical standard or normal lens. See also, short lens.

Wi-Fi
A technology that allows for wireless networking between one Wi-Fi compatible product and another; stands for Wireless Fidelity.

zoom lens
A lens that adjusts to cover a wide range of focal lengths.

Index